IMAGES
of America
THE JEWISH COMMUNITY
AROUND
NORTH BROAD STREET

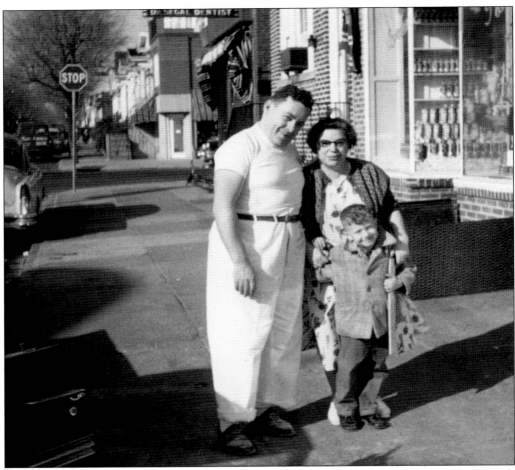

The Jewish community of Philadelphia is underpinned by the supportive lifeline of its Jewish neighborhoods. The cohesive fabric that tied a neighborhood of families and friends together in the 20th century gave rise to the development of a great community of Jewish people who considered themselves Philadelphians first and foremost. Sam and Ida Rosen (of blessed memory) loved their community of Logan off North Broad Street and represented its very pulse at one location—4755 North 11th and Louden Streets—in their bakery business, after migrating up North Broad Street from Seventh Street and Girard Avenue. The Rosens served thousands of people with their daily bread for 40 years. It is with great admiration that this author knows the Rosen family, Rita Rosen Poley, and her brother Marty Rosen, and is proud to share with the general population what a Jewish community really means to its longtime inhabitants years after they sold their homes and left their close-knit neighborhoods

Dedicated with great appreciation and pride to Sam and Ida Rosen, who passed away on October 30, 2001, and November 21, 2001, respectively.

IMAGES
of America

THE JEWISH COMMUNITY
AROUND
NORTH BROAD STREET

Allen Meyers

ARCADIA

First published 2002
Reprinted 2004

Published by Arcadia Publishing,
an imprint of Tempus Publishing Inc.
Portsmouth NH, Charleston SC, Chicago,
San Francisco

Printed in Great Britain

Library of Congress Catalog Card Number: 2002101053

For all general information, contact Arcadia Publishing:
Telephone 843-853-2070
Fax 843-853-0044
E-mail sales@arcadiapublishing.com
For customer service and orders:
Toll-free 1-888-313-2665

Visit us on the Internet at www.arcadiapublishing.com

On the cover: "Yum yum" is a phrase to describe our collective memories of Jewish neighborhoods in Philadelphia. At Cakemasters Bakery, you had to select a number and wait in a line on a Sunday morning. (Courtesy Susan Baliban.)

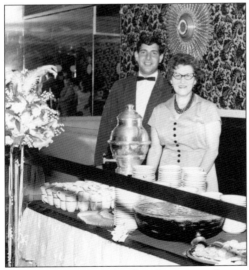

Traditionally, with food and song, we have celebrated our Jewish heritage in Philadelphia for more than 250 years. *Left:* Anta Zalben and her son Barry catered many affairs from their home at 10th Street and Wyoming Avenue. (Courtesy Michelle Gusdorff.) *Right:* Bobbie and Henry Shaffner, noted Philadelphia songwriters, welcome thousands of visitors to Philadelphia along with Billy Penn annually via their melodies about the city they love the most. Bobbie grew up in West Oak Lane at 6432 North 16th Street.

CONTENTS

ACKNOWLEDGMENTS

Many thanks go to the hundreds of people and former residents of Philadelphia's old Jewish neighborhoods whom I personally interviewed in the past year. Some may remember the visits I paid to their homes with a tape recorder, camera in hand, and a request for old family photographs.

The project of writing about old Jewish neighborhoods dates back to the late 1970s, when I attended Gratz Hebrew College near the old Jewish Hospital (now the Albert Einstein Medical Center) at 10th and Tabor Roads. My grandparents, Rose and Louis Ponnock, had passed away in the summer of 1978. Upon returning to classes in the fall, Prof. Rela Geffen and Prof. Nora Levin (of blessed memory) suggested to honor my grandparents by acknowledging their past achievements and by recalling where they once lived. Reflection about the past seemed to engulf my daily thoughts and amazement about how Jewish life flourished vis-à-vis ordinary Jewish people in Philadelphia. So, one warm September evening in 1978, as classes resumed for the fall semester, I filled my time between classes with a walk from Gratz College to the neighborhood of Logan in search of the Beth Judah synagogue on north 11th Street.

I found myself nourishing a feeling of belonging by attendance at evening services with people who were complete strangers yet somehow connected to one another. When it came time to recite the *Kaddish* (the prayer for the deceased), I realized that I had become an instant member of the community as I stood up with other mourners. The power of community is a major component of Jewish life. After the services and a small *Kiddush* meal, the men shared with me their concerns and the challenges they faced. The older men explained about the decline of their neighborhood, which meant the closure of their businesses, fewer men at *minion* (religious) services day and night, the loss of neighbors due to poor health, and the migration of many to more stable Jewish neighborhoods, especially in the Oxford Circle where the author lived.

The seeds for this book predate May 2001, when I gave a lecture at Reform Congregation Keneseth Israel in Elkins Park, Pennsylvania, on the subject of the future of Jewish neighborhoods. Michelle Gusdorff came up to the podium after the lecture and offered to share her insights of her mother's maiden adventure into the world of catering from hosting and preparing the *Oneg* (a special *kiddush*) refreshments after Friday night services at the Beth Judah synagogue on North 11th Street. The book was born that night to celebrate the lifetime achievements and validate the contributions Jews had made to North-Northwest Philadelphia.

—Allen Meyers

INTRODUCTION

The move northward out of William Penn's city accelerated in the period following the Civil War for most families. German Jewish immigrants crowded in the Franklin Square neighborhood north of Market Street and east of Broad, where three synagogues—Mikveh Israel, Beth Israel, and Keneseth Israel—had built their new edifices. Through the end of the 19th century, as population increased, transportation improved, and less crowded conditions became available farther away from the city, the communities and the families that comprised them continued to move north-northwest until they approached the newly built brownstone mansions that lined North Broad Street.

The first synagogue to occupy an address on North Broad Street came in 1871, when Rodeph Sholom erected its first edifice, designed by the well-respected Philadelphia architect Frank Furness. Reform Congregation Keneseth Israel built a very tall synagogue in 1892 north of Columbia Avenue, joining the Mercantile Club, which still exists as a hall at Broad and Master Streets, both built by German Jewish business owners. Jewish immigrants from central Europe established new neighborhood institutions in the Northern Liberties district as the German Jewish population resettled on the west side of Broad Street in the last few years of the 19th century.

Marshall and Girard Avenues became a hub of small Jewish merchants who patronized such well-known eateries as the Capital, the Ambassador, and the famous Gansky. The southeast corner of Broad and York Streets housed Congregation Mikveh Israel, the Hebrew Education Society (later Gratz Hebrew College), and Dropsie College, which served the entire community from the first decade of the 20th century through the 1980s. Also up North Broad Street was the Federation of Jewish Agencies, which united many smaller charity groups into one entity in 1901 with a dozen participants. Those organizations included the Hebrew Sunday School Society and the original Young Men's Hebrew Association at 1616 Master Street.

Public transportation to the neighborhood was provided both eastbound and westbound between the Delaware and Schuylkill Rivers. The competition among the many companies vying for local business led to 30 lines being built to serve the area. Jewish funeral homes made their way up North Broad Street from Pine Street in South Philadelphia to have access to the migrating Jewish population of Philadelphia in the 1920s. Levine's, Goldstein's, and Reisman's were joined by Berschler's, Rosenberg's, and Rapael Sack's, which later moved farther north along North Broad Street with many families. Jewish caterers also flocked to North Broad Street and occupied prominent corners such as the Broadwood Hotel at Broad and Vine Streets, which hosted many parties catered by Savadov & Getson. Kauffman's and Alexander's laid retail claim to North Broad Street along with Harry Davis and Rosenberg's. There were such

places as Ambassador Hall, the Majestic Hotel, or Jefferson Hall, large ballrooms filled with people who wanted to celebrate special occasions with other members of the community with food and music. Farther out of the city, northern suburbs were served by the Reading Railroad train station near North Broad Street and Lehigh Avenue. Since people were moving to different parts of the city, public transportation was essential to getting to and from shopping, leisure, sports, and dining venues throughout Philadelphia.

In the beginning of the 20th century, the completion of the North Broad Street subway terminal at Broad and Olney Avenues brought thousands of Jewish residents to Logan and the Broad and Olney area. The Jewish Hospital and the Jewish Orphanage at Chew and Church Lanes gave hope to many members of the Jewish community. The location of the Jewish institutions themselves gave rise to the future migration patterns of Philadelphia's Jewry. New homes were built in Logan, Olney, and Oak Lane as Jewish neighborhoods expanded in a northward pattern following World War I. Many remember sledding on the grounds of the Jewish Hospital, the joys of the movies at Broad and Olney Avenues, the delicious delicatessen food from Ulitsky's on North 11th Street, and especially Rosen's famous rye bread. As men returned from military service after World War II, they married and found employment and affordable housing.

Today, the move to the northern suburbs continues. The best way to illustrate the migration northward is to travel to the synagogues that have relocated or merged: Keneseth Israel, Rodeph Sholom, Temple Judea, Beth Judah, Ahavath Israel, Beth Shalom, Emanu-El, Temple Sinai, Adath Jeshurun, and Ramat El. Synagogues have followed and mirrored the migration paths of the Jewish people ever northward. The suburbs in between include many Jewish families in Elkins Park, Abington, Dresher, Yardley, and north to New Hope along the Delaware River. This book is a treasure trove of memories that describe the lives of many Jewish Philadelphians, specifically those in the neighborhoods around North Broad Street. The photographs, oral history, and testament of the community are an invaluable tool that will serve to validate the existence of Philadelphia's Jewry for generations to come. *The Jewish Community around North Broad Street* gives us the story of this community, which in the 20th century took the advice of Horace Greely to Horatio Alger to "go north." It is my hope that you and your family will enjoy this book.

—Rabbi Fred Kazan

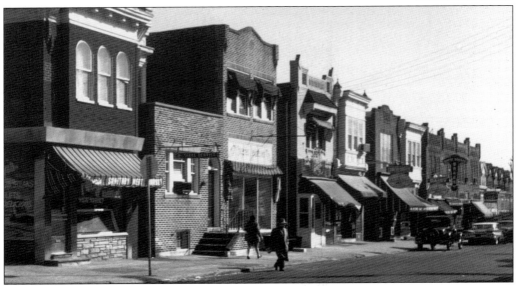

Pictured *c.* the 1950s is the business district in Logan below Louden Street.

One

JEWISH COMMUNITY
INSTITUTIONS

The development of the Jewish community in Philadelphia took a decisive turn at the end of the 19th century with the relocation of the Jewish Hospital, founded in 1864 in West Philadelphia by B'nai Brith Society, to Old York and Tabor Roads, further encouraging the migration northward. Fresh air and access to the countryside prompted the placement of the Jewish Asylum and Orphanage on Chew Avenue and Church Lane in 1873. The arrival of a Jewish institution for the aged and infirmed on the large tract of land on the Jewish Hospital grounds, much like the many other institutions in this chapter, helped define boundaries of the Jewish community. The Jewish Hospital, situated on 20 acres of land east and south of Broad and Olney Avenues, grew in stature and size as new departments were opened with specific goals for the treatment of patients. (Courtesy Philadelphia Archives Center.)

The tenets of Biblical Judaism include an important aspect of Jewish life still relevant today. Children are obligated to care for their aging parents and not to forsake them when they are elderly. The community at large becomes a caretaker of the elderly and aids in the development of facilities to care for them. The Jewish Hospital expanded this idea with a program created in the 1890s to meet the needs of individuals of the Jewish faith in a wholesome environment. Communal dining is an essential element that binds the individuals into a community along with the prescribed rituals associated with Jewish life. (Courtesy Philadelphia Jewish Archives Center.)

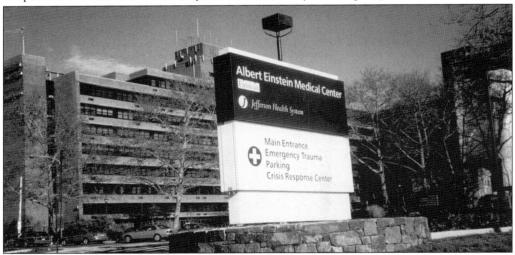

The drive to become a medical center par excellence resulted in the institution adopting the name of Albert Einstein in the early 1950s just as an expansive building plan took effect. The Jewish Hospital trustees realized the great opportunity to service the general population after World War II as the client base changed in the surrounding neighborhoods. The prestige of being born at the Jewish Hospital remained intact as the Einstein Babies public relations campaign took effect in the 1980s. Today, the Albert Einstein Medical Center looks to the future of serving people of all creeds and religions in the northern suburbs as it branches out of Philadelphia. (Courtesy Philadelphia Jewish Archives Center.)

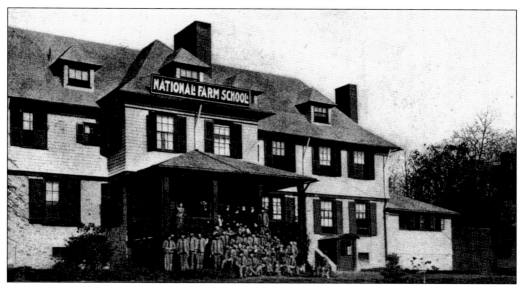

A progressive outlook for the future of the American Jewish community took hold in the 1890s as many east European Jews migrated to the United States. Rabbi Joseph Krauskopf, who in the 1880s accepted the pulpit at Reform Congregation Keneseth Israel, a German Jewish synagogue, went to Russia on a fact-finding mission and to meet with Leo Tolstoy. As a result of this meeting, the movement known as Odam Olam, or "return to the soil," began. It appealed to many Jews worldwide. The result was the creation of the National Farm School (1896). (Courtesy Reform Congregation Keneseth Israel Archives.)

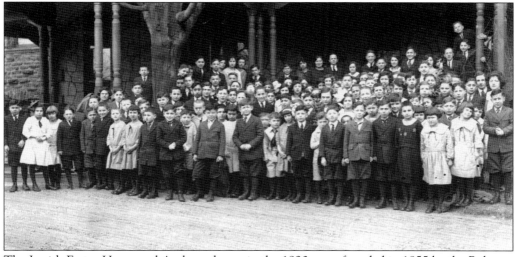

The Jewish Foster Home and Asylum, shown in the 1920s, was founded in 1855 by the Rebecca Gratz family. It provided shelter and hope to many disconnected German Jewish and east European Jewish children after they came to the shores of America. The concepts of community living and family values took place at the institution situated off Chew Avenue and Church Lane only a mile from the new home of the Jewish Hospital in the 1870s. The many children who found refuge in the home grew up to become responsible members within the Jewish community. The home closed in the 1950s. (Courtesy Jewish Family Service of Philadelphia.)

Jewish people were excluded from many social events held by the general community, so they formed their own country club. At the Philmont Country Club, Jews found refuge from urban chores, relaxed in the countryside, and enjoyed the growing popularity of golf in the early 1900s. Members of the community sojourned from North Philadelphia via the Reading Railroad line to Trenton and were met by a horse-drawn bus to take them to the club. The addition of a swimming pool attracted even more members. The very name of the country club denoted the facility as a Philadelphia–Montgomery County destination.

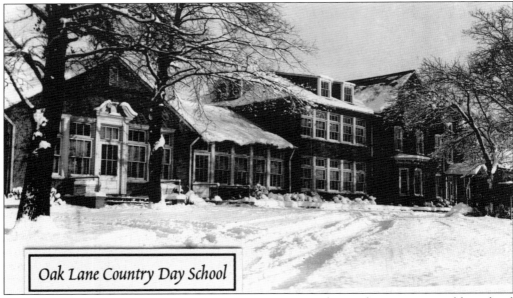

Oak Lane Country Day School

The Oak Lane Country School opened in 1916 to provide an alternative to public school education. The German and east European Jewish community formed a board that included many prominent members of the community, including Judge Horace Stern, who cosigned a $10,000 note from the bank to start a school where the individuality of the child was the focus. The school was situated on Oak Lane Road east of North Broad Street. The school grew from 7 to more than 300 students in its first 10 years and accepted students regardless of their nationality or religion. Today, the school is located in Blue Bell and maintains its original mission. (Courtesy Ruth Kohn.)

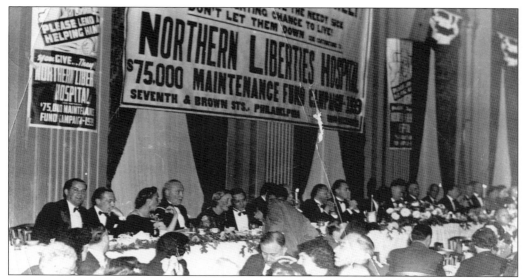

Northern Liberties Hospital, the third Jewish hospital in Philadelphia, served the Seventh and Girard Avenues neighborhood, especially during the citywide smallpox epidemic of 1903. The geographical community served by the hospital stretched east of North Broad Street to Front Street and from Spring Garden Avenue north to Montgomery Avenue and included roughly 30,000 people; most of these were German Jews through the late 19th century but included central European Jews by the beginning of the 20th century. The new Northern Liberties Hospital served as a birthing station for a new generation of Jewish people between 1918 and 1948. (Courtesy Philadelphia Jewish Archives Center.)

The Pannonia Beneficial Association, begun in the 1880s in North Philadelphia, took great pride in sponsoring many charity drives for the Philadelphia Jewish community and had thousands of fun-loving members. Themed dinners and dances attracted a large crowd, were usually held at the Philadelphia Athletic Club on North Broad and Vine Streets, and were catered by Hy Getson. Pannonia migrated with its members from its Seventh and Girard social center to the top of North Broad Street next to the Shelron and Baltimore Markets. In 2002, Pannonia migrated for a third time, to Feasterville. (Courtesy Philadelphia Jewish Archives Center.)

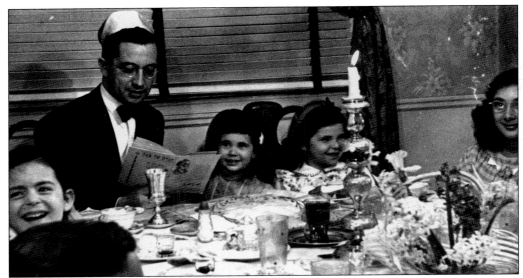

The Hebrew Sunday School Society, formulated in 1838 by Rebecca Gratz, filled a void in the weekly calendar of Philadelphia's Jewry. Abraham Alvin Blumberg, a principal at the Solis Cohen public school, led classes for the Hebrew Sunday School Society from its headquarters at Broad and Pine Streets. The push for a coeducational format was key to the success of this institution. Jewish children of all economic households were tutored in Jewish history, customs, and holidays. They gained pride in their religion through dedicated teachers who taught classes in various locations throughout the city. Blumberg enjoyed putting into practice what he taught, as at this community Passover Seder held in 1945. (Courtesy Evy, Sylvia, and Tossie Blumberg.)

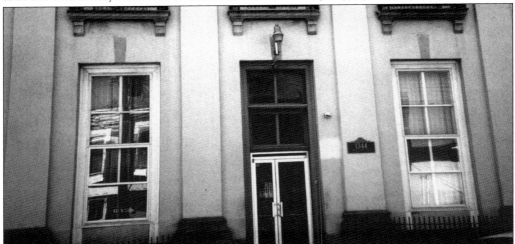

Gratz College came into existence by way of the Hyman Gratz trust. Gratz was a member of Mikveh Israel synagogue in 1895. Dr Solis Cohen implemented the wishes of Hyman by creating an institution that conducted courses in Jewish history and religion and produced Hebrew school teachers, which were in great demand at Conservative and Reform congregations throughout Philadelphia. The cornerstone of Jewish education came to rest at the campus of the new Mikveh Israel site located at Broad and York Streets in 1909. Great scholars associated with Gratz included Dr. Cyrus Adler, Moses Drospie, and Mayer Sulzberger. By 1962, Gratz College relocated to Logan, where it stayed until the mid-1980s.

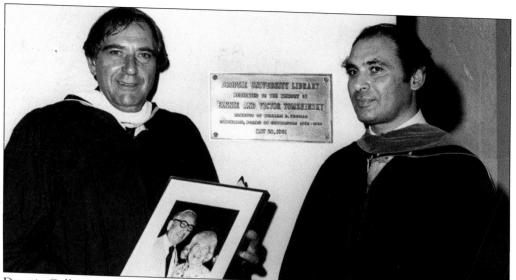

Drospie College was founded by Moses Aaron Dropsie, a street railway magnate. He found a home for his school in Philadelphia on the Mikveh Israel campus in 1909. The college was open to all people and centered on Hebrew and Cognate learning. Great scholars such as William Chomsky, Uzi Adini, David Rabiya, Abraham Marthan, Sam Lachs, and Sam Kurland earned their doctorates at Broad and York Streets and later taught at Gratz College, before Jewish Studies became a general college-accepted curriculum. Dr. Hayim Sheymnin is pictured with Abraham Isaac Kastsh, president of Dropise, in 1970. The college merged with the University of Pennsylvania in the 1980s. (Courtesy Hayim Sheymnin.)

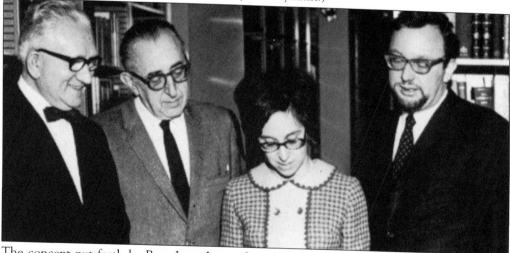

The concept put forth by Rev. Isaac Lesser from Mikveh Israel in the 1860s for a rabbinical college located in Philadelphia evolved into the establishment of many institutions after his death. The Hebrew Education Society, the Hebrew Sunday School Society, the Talmud Torah and Jewish Education Centers, and Gratz and Dropsie Colleges gave Philadelphia a world-class reputation for quality Jewish education. The Reconstructionist Rabbinical College, founded by Rabbi Mordechai Kaplan on the concept that Judaism is a civilization, occupied its first seminary in the heart of North Philadelphia at 2308 North Broad Street in 1968. (Courtesy Jewish Exponent.)

Simon Miller, a well-respected shirt manufacturer, joined the ranks of the Jewish community in the late 19th century. A generation earlier, Rev. Isaac Lesser had started a Hebrew literary society and published Jewish literature and newsletters such as the *Occident*, a nationally read Jewish weekly newspaper. Lesser's Jewish Publication Society came back full of life and vigor through Miller 20 years after Lesser's death. Miller, elected president of the Jewish Publication Society, fostered a love for Jewish knowledge, which led to the first English translation of the Old Testament (edited by Max L. Margolis), during his 20-year tutelage of the Jewish Publication Society in 1917. (Courtesy Jeff Miller.)

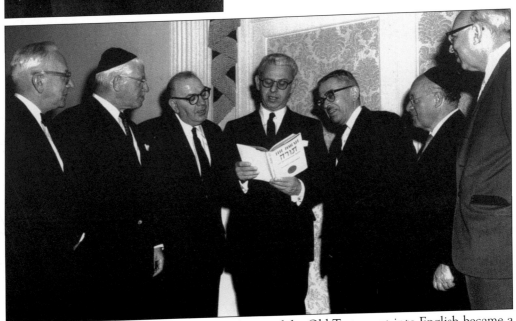

For the second time in a century, the translation of the Old Testament into English became a major project and undertaking of the American Jewish community under the auspices of the Jewish Publication Society. Dr. Harry M. Orlinsky received help from Dr. H.L. Ginsburg and Dr. Ephraim Speiser to update the translation again in 1963. (Courtesy Jewish Exponent.)

Shelters and homes for Jewish children operated throughout the city, specifically in South Philadelphia, North Philadelphia, and in the Oak Lane area along North Broad Street. Four organizations merged in 1950 to create the Association of Jewish children at 1301 Spencer Street. The organization served mostly girls and only a handful of boys. The children were united by the feeling of family fostered at the organization and by the acknowledgment of Jewish holidays and traditions, such as the celebration of Purim and the reenactment of the story of Queen Esther. The institution closed in the late 1960s. (Courtesy Dorothy Cohen.)

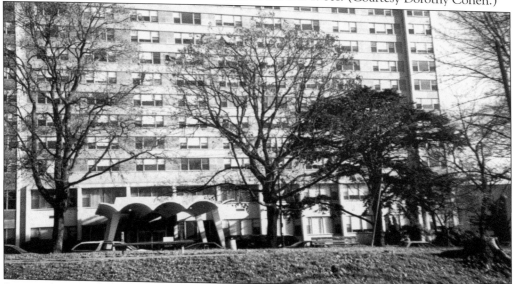

Increased life expectancy and the massive wave of Jewish migration from Europe after World War II led to an increase in the need for care of the elderly. A major breakthrough in care for the elderly took place with the opening of apartment complexes to house residents who were still independent but would benefit from assisted living in modern facilities. One such complex was the York House at 5301 York Road, off North Broad Street below the Jewish Hospital. The campus moved to Horsham in 2001, and the residences were absorbed by Temple Health Care.

17

As Jewish people moved in the 1890s into northwest Philadelphia, specifically Germantown, so did Jewish merchants and businesses. The Cedars of Tel Aviv nursing home, run by Rabbi Hiatt and designed by architects Magaziner and Potter, opened in 1948. Availability of kosher food provided the key to this institution, which was the first of its kind in the city. Rabbi Hiatt retired in 1965, and the facility was bought by a group of men that included Murray Spiegal, Milt Jacob, and Robert Krevlin, who ran it after the introduction of Medicare, which enabled older people to access nursing homes regardless of their incomes. The former hotel was demolished in the 1990s and a modern facility built. (Courtesy Maplewood Manor Nursing Home.)

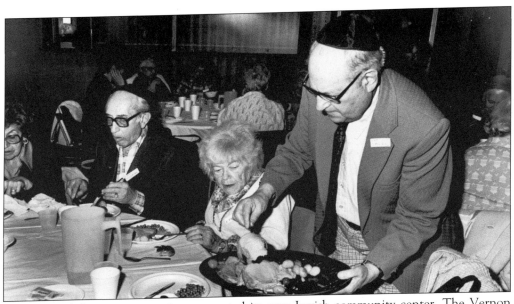

Each area of the city at one time supported its own Jewish community center. The Vernon Road or Northwest Jewish Community Center began operations in the early 1950s as the neighborhood expanded with new homes. The Germantown and Mount Airy Jewish communities joined in sponsoring the Northwest Jewish Community Festival, conducted by the Jewish Community Relations Council and led mostly by volunteers. Food and music from various parts of the world were available, Yiddish stories were told, and Israeli and Klezmer music accompanied the festival along with art, crafts, and games. (Courtesy Jewish Exponent.)

Two

NORTH BROAD STREET SYNAGOGUES

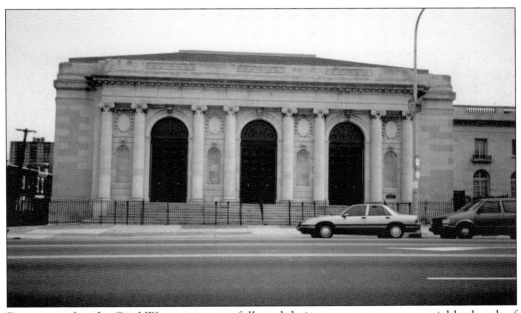

Beginning after the Civil War, synagogues followed their congregants to new neighborhoods of three-story brownstone mansions and row houses that represented most of the North Broad Street community from Spring Garden Avenue north to York Street. Jewish houses of worship built directly on North Broad Street displayed a sense of arrival in Philadelphia's society. This hopscotch construction mirrored the migration path of the Jewish residents, which accounted for the building of six synagogue edifices stretching along North Broad Street. The congregation of Mikveh Israel, founded only 30 years before the Revolutionary War, relocated to different parts of the city throughout its long history. It returned to its original location in 1976 and included a new institution: the Museum of American Jewish History.

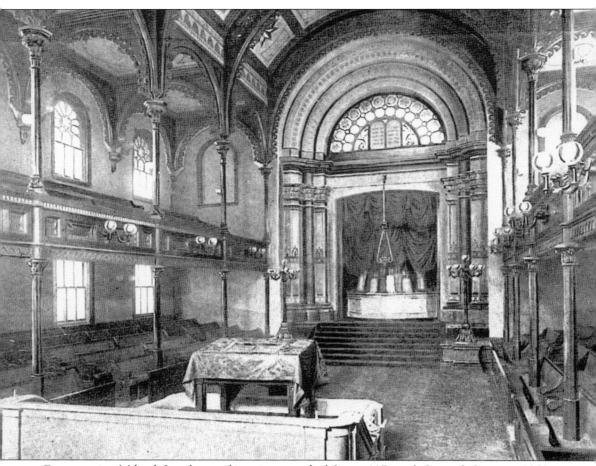

Congregation Mikveh Israel moved into its second edifice at 117 north Seventh Street in 1859. This was in the Franklin Square neighborhood only several blocks from its first house of worship at Third and Cherry Streets. The separation of Rev. Isaac Lesser from the pulpit and his development of another synagogue (Beth El Emeth) in 1857 at Sixth and Spring Garden Avenues accelerated Mivkeh Israel's desire to establish a more focused vision as the leader in Philadelphia's Jewry. Its close alliance with the Hebrew Education Society (located at Seventh and Wood Streets) helped it retain its position as a leading congregation. The design of Mikveh Israel's interior is consistent with Sephardic traditions: the placement of the reader's stand in the middle of the synagogue is within a prescribed allotment of footsteps to the holy Ark, where the Torahs are kept. Before his death in 1897, Rev. Sabato Morais, elected in 1851, led this historic congregation throughout the late 19th century and contributed to many important milestones, including the construction of the Jewish settlement of Woodbine in southern New Jersey and the publication of a chronicle of Jewish life in Philadelphia. (Courtesy Dropsie College Archives.)

Rodeph Sholom, or "congregation of peace," was founded as the second Jewish congregation in Philadelphia at the conclusion of the Revolutionary War in 1795 and served an emerging German Jewish population. Its move to the 600 block of North Broad Street in 1871 to an edifice designed by well-known Philadelphia architect Frank Furness signified the beginning of a new era in Philadelphia's Jewry and the emergence of a well-respected community with a distinctive address separate from Mikveh Israel or Keneseth Israel. (Courtesy Dropsie College Archives.)

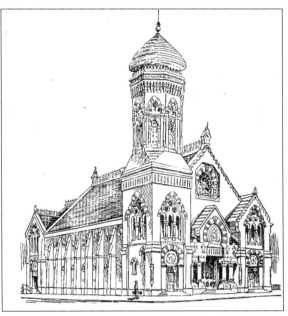

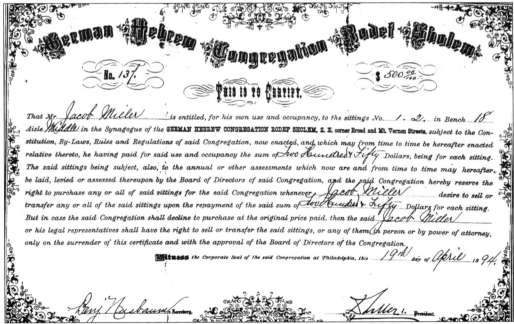

Rodeph Sholom rose to lead the Jewish community vis-à-vis not only its edifice, location, or rabbis but by its membership. The forward thinking of its congregants led to the development of an American synagogue community where lay leaders joined their spiritual leaders to reform Judaism in America. Dr. Marcus Jastrow came to Rodeph Sholom in 1866 and formulated new ideals within the synagogue to include an abridged service, a choir of Jewish and non-Jewish voices, an organ, the introduction of family pews, the elimination of the balcony for women only, and the discontinuation for bidding on certain portions of the service. Finally, the Jastrow prayer book was adopted and the era of seat holders gave way to more decorum.

The move to North Broad Street by Congregation Rodeph Sholom after the Civil War served two generations of German Jewish families into the 1920s with progressive reforms and rabbinical leadership. In the 1920s, Rabbi Louis Wolsey came to serve Rodeph Shalom and led his congregation into the future with a $1 million building campaign. At the request of Rabbi Wolsey, the congregation overcame the excavation of the North Broad Street subway at its doorsteps, the changing of the surrounding community, and the stiff competition posed by other large congregations. The sentiment was to remain on North Broad Street and build a new synagogue, designed by Simon & Simon architects with a Moorish motif and limestone and granite edifice. The new building could seat more than 1,650 people and was completed in 1927. A later, more modern community center seating 700 people added to the appeal of Rodeph Shalom for the next generation.

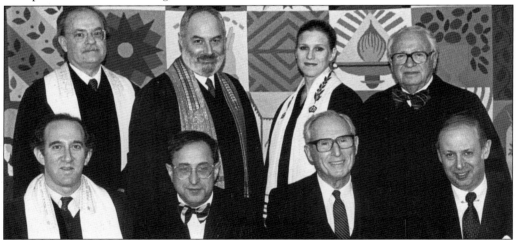

Rabbi David Wice (of blessed memory) came to Rodeph Shalom in the late 1940s to lead this congregation into the post–World War II period. Full of hope and vigor, the congregation decided to maintain two branches, one in the city and the other in the northern suburbs. The dual identity of this congregation gave hope to both urban and suburban vantage points of Philadelphia's Jewry. The symbolism for this unique development in American Jewish history is a tapestry designed by Mrs. Evelyn Keyser. The work unites Jewish history and art. The rabbinical leadership of the 1990s included Rabbis Simeon Maslin, Richard Steinbrink, Patrice Heller, David Wice, Rabbi Elliot Hollin, David Kaufman, and laymen Dr. Robert Kahn and Michael Goldberg. (Courtesy Jewish Exponent.)

Keneseth Israel, the fourth Jewish congregation, formed in 1847 to serve the growing German Jewish population. The members voted to move the synagogue from the building at Sixth and Brown Streets, built in 1864, to a site at 1717 North Broad Street (above Columbia Avenue). In 1892, Keneseth Israel thus became the second synagogue to take up residency on North Broad Street. The architecture reflected an Italian Renaissance form similar to the new city hall (limestone) complex under construction only two miles farther south, where Broad Street crossed Market Street, and incorporated symbols from St. Mark's Cathedral (tall tower) in Venice and Mosque of Omar in Jerusalem. (Courtesy Dropsie College Archives.)

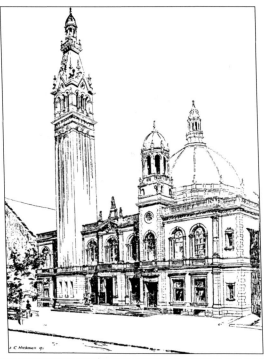

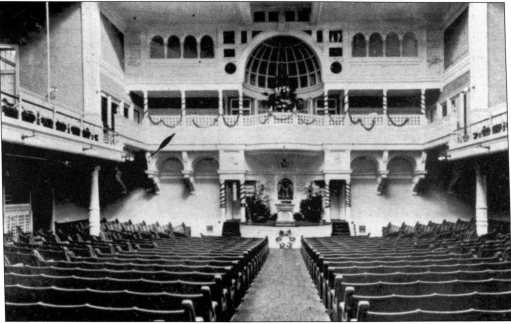

Rabbi Joseph Krauskopf, an early graduate of the Hebrew Union Rabbinical College, came to Keneseth Israel in 1887. Krauskopf's vision was the inspiration to change the nature of the congregation to fit the times. They eliminated the Bar Mitzvah ceremony and the blowing of the *shofar* during the high holy days. The introduction of Sunday services along with his sermons and lectures captivated a growing congregation. (Courtesy Dropsie College Archives.)

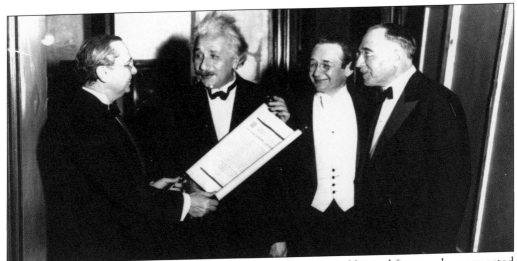

Keneseth Israel owes its leadership during the 20th century to rabbinical figures who connected families to one another, as in the long-ago days when neighborhoods had synagogues as their core. During Rabbi Henry Fineshriber's era (1923–1949), the mobile nature of the German Jewish community via the automobile and passenger trains made it possible to live in a variety of localities yet remain connected with the synagogue of one's youth. Albert Einstein, who resigned from the Royal Prussian Academy of Sciences and left Nazi Germany in 1933 to go to Princeton University to accept a professorship in advanced scientific studies, did not have the luxury of keeping his childhood synagogue. Keneseth Israel granted him an honorary membership. (Courtesy Keneseth Israel Archives.)

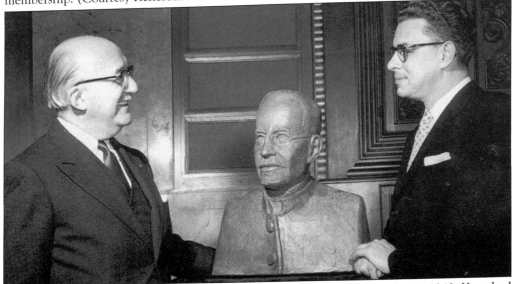

Rabbi Bertram Korn assumed the role of rabbi from Rabbi Henry Fineshriber in 1949. Korn had become a bar mitzvah under Rabbi Fineshriber (after the reinstitution of the ceremony in 1931). The continuing movement of Jews farther north of the city after World War II served to fuel Korn's determination to lead his congregation into its second century. Merger talks with Rodeph Shalom failed to produce any result, and in 1957, Keneseth Israel moved their Torahs to their new neighborhood closer to Elkin's Park and Jenkintown. (Courtesy Keneseth Israel Archives.)

The expansion of the German Jewish community during the latter 19th century led to the formation of seven new synagogues. Congregation Adath Jeshurun, founded in 1858, moved to various locations, finally landing in an ornate Moorish edifice at Seventh Street and Columbia Avenue in 1886. It shared its congregants from the neighborhood above Girard Avenue with Beth Israel and Ohev Zedek. Adath Jeshurun vacated its synagogue 25 years later and turned it over to another synagogue. Today, the building is on the National Register of Historic Places. (Courtesy Allen Meyers.)

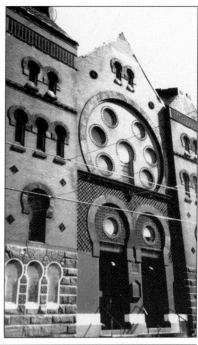

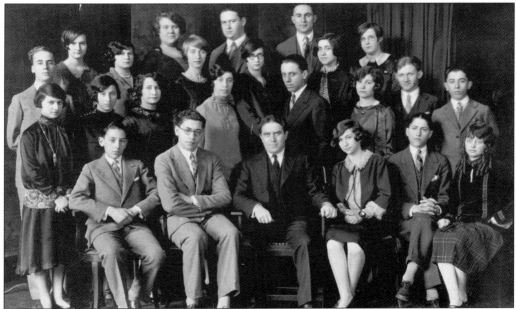

The long history of Congregation Adath Jeshurun is made up of the stories of small groups of families that made up the mosaic of this synagogue. Helene Berg Strauss grew up at 2235 north Park Avenue off North Broad and Diamond Streets and developed lifelong friendships with other people who had graduated from her 1925 confirmation class. Her classmates included Lorna Greenberg, Sylvia Davis, Israel Strauss, Irwin Brod, Elsie Herz, Louis Sichels, Debra Greenstone (daughter of Julius Greenstone of Gratz College fame), Mindell Kaplan, and Rosalyn Sheiman. (Courtesy Helene Berg Strauss and Josie Rosenthal.)

The great leaders in Philadelphia's Jewish community during the 20th century were the rabbis. Rabbi Yaakov Roseberg (of blessed memory) did his preliminary pulpit training at Har Zion as an assistant rabbi in the 1950s under the tutelage of Rabbi David Goldstein. The warmth that he learned to convey to his congregants was revered throughout Philadelphia. Following in the footsteps of Rabbi Max Klein at Congregation Adath Jeshurun meant making some great adjustments to decorum, which Rabbi Rosenberg made as the synagogue migrated out of North Philadelphia into the northern suburbs after its founding more than 100 years earlier. Rabbi Rosenberg stood for Russian Jewry's right to emigrate to Israel in the 1960s, as did Yaakov in the 1990s. He left a whole generation of followers with *ruach*, the uplifted spirit to press on with their lives (Courtesy Jewish Exponent.)

The elevation of a synagogue to prominence in the community is the duty of its rabbi. Congregation Adath Jeshurun is one of the success stories, but with additional chapters. Rabbi Max Klein gave his synagogue an added boost when he arrived, just as the congregation was relocating to its faithful address in the 2200 block of North Broad Street above Diamond Street in 1911. The creation of a Hebrew prayer book set Adath Jeshurun apart from all the other congregations, which remained the newest addition to Jewish houses of worship until Rodeph Shalom rebuilt its synagogue 15 years later, in 1926. Philadelphia became clogged with Jewish houses of worship from the Delaware to the Schuylkill Rivers with more than 110 synagogues as early as 1900. (Courtesy Adath Jeshurun Archives.)

After his graduation in 1919, Rabbi Mortimer Cohen began service in Logan along North Broad Street, beginning a new era in Philadelphia Jewish history. Congregation Beth Sholom, or "house of peace," served the community of newly built row houses, open front porches, and tree-lined streets before American involvement in World War I. One generation later, in 1952, the congregation opted to relocate its religious school to Elkins Park. The split nature of the congregation came to an end in 1959, when its edifice on Old York Road, designed by Frank Lloyd Wright, opened its doors. (Courtesy Beth Sholom Archives.)

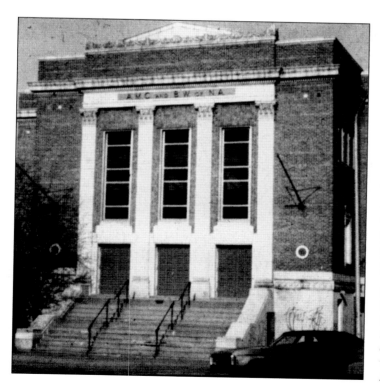

Rabbi Cohen tended to his congregation with great zeal and even offered worshippers the opportunity to spend time with him on the Jersey Shore, where he led B'nai Israel, in Pleasantville, New Jersey, during the summer. Rabbi Cohen served as a model to his students when he wrote his most famous book, *Pathways through the Bible*. The age of their synagogue allowed Rabbi Cohen to oversee and sell the idea of building a new synagogue outside of the city, which took place in the late 1950s. (Courtesy Allen Meyers.)

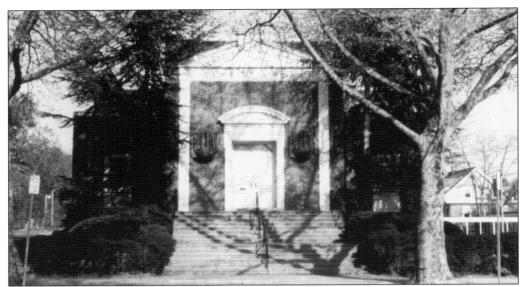

The formation of the Oak Lane Country School and money donated from the Reform Congregation Keneseth Israel and Rodeph Sholom allowed for the formation of the third reform congregation, Temple Judea, in 1930. Rabbi Meir Lasker, a Russian-born immigrant, had led the congregation for more than 40 years when it closed in the early 1980s.

A collection of Judaic art turned Temple Judea into more than just a beautiful synagogue. The collection of many pieces of fine art came from Europe, at the time under the siege of the Nazis, and included plates, candlestick holders, and Torah breast plates made of precious metals. The hope for the continuation of Temple Judea came to an end in 1982, when a site in Huntingdon Valley, at Meeting House and Susquehanna Roads, came under attack by the local residents, and the deal was dead. The legacy of Temple Judea survived through its extensive art when it was suggested to turn the collection into a museum housed at Reform Congregation Keneseth Israel in Elkins Park. (Courtesy Rita Poley.)

Three
JEWISH FUNERAL HOMES

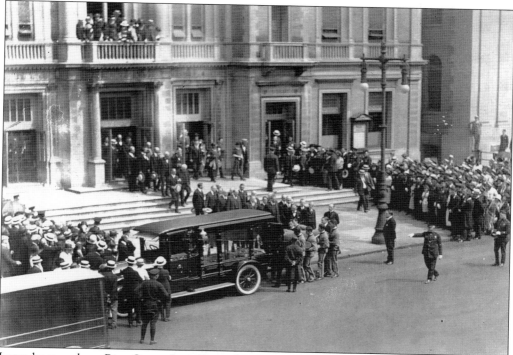

Large homes along Pine Street from Second to Seventh Streets once provided ample room to accommodate 19th-century Jewish funerals. But as the community grew, their need for such services grew. Eight Jewish cemeteries in and around Philadelphia were created at the end of the 19th century and beginning of the 20th. Shapiro & Sons, the oldest memorial dealer in the city, was located in the North Liberties district at Fifth and Thompson Streets, and 16 Jewish undertakers served an ever larger Jewish community in the early 1900s. The death of well-known Rabbi Joseph Krauskopf in 1923 created a spectacle of activity never seen before in the city. The service was held on North Broad Street in the large sanctuary, where hundreds of mourners, including many dignitaries, could participate. (Courtesy Keneseth Israel Archives.)

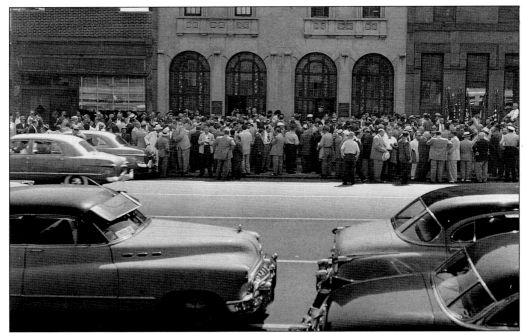

Funerals of Jewish community leaders often attracted large crowds of mourners. For the funeral of Max Slepin, the Philadelphia police closed off a portion of North Broad Street to automobile traffic to accommodate all who attended the service at Rosenberg's Funeral home, located at 2009 North Broad Street. (Courtesy Goldstein's Funeral Directors.)

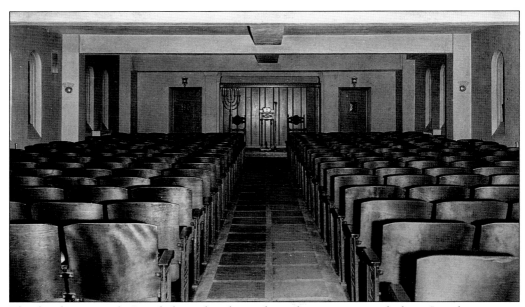

The development of a Jewish funeral parlor took on the appearance of a large Jewish sanctuary within a synagogue. The era also lent itself to the décor, with stationary wooden seats of the type usually found in the movie houses that were cropping up. (Courtesy Raphael Sacks.)

Jewish funeral homes on North Broad Street numbered 13 by 1930. The familiar names of the Jewish funeral parlors included Asher, Berschler, Wisnoff, Molnick, Stillman, Levine, Raphael, Sacks, Rosenberg Goldstein, Reisman, Kahn, and Rosen. The somber, light limestone facades that came to symbolize the Jewish funeral homes on North Broad Street was in stark contrast to the earth-tone brownstone that characterized the housing stock of the community. The use of air conditioning as an advertising tool for any memorial chapel came as a relief to the weary mourners during the 1940s, especially in the peak of summer.

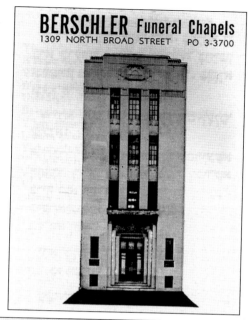

BERSCHLER Funeral Chapels
1309 NORTH BROAD STREET PO 3-3700

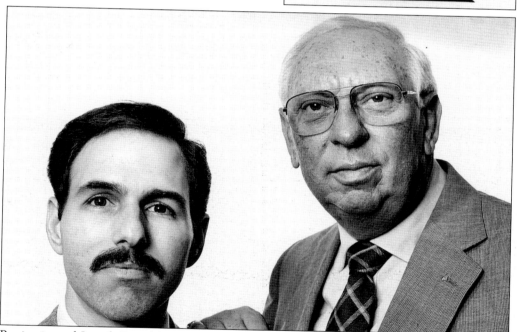

Benjamin and Joseph Berschler started their funeral business in Camden, New Jersey, during the 1920s. The men had attended Eckels School of Embalming at Temple University. The second generation included David and Leonard, sons of Benjamin, who opened a location at 1927 North Broad Street in 1946. Joseph's son, Albert, joined Asher-Berschler at 1309 North Broad Street. Another facility was opened at 4300 North Broad Street in Logan in 1961. During the 1970s, family business owners sometimes had to reach out not to sons but to sons-in-law, including Howard Shenberg, pictured with his father-in-law, Albert, to advance the business into the future through a bond of trust. (Courtesy Howard Shenberg.)

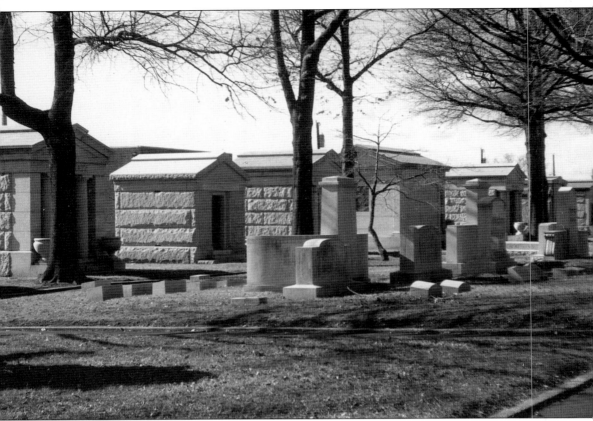

The Mount Sinai Jewish Cemetery opened in 1850s in the urban suburbs of then-rural Philadelphia. The German Jewish community created several cemeteries on Bridge Street in the Frankford, section including Adath Jeshurun Cemetery, adjacent to Mount Sinai. The final resting places for many prominent Jews of the 19th century took the form of an elaborate and well-built, above-ground burial vault or family mausoleum. Like other establishments, Jewish cemeteries and their locations represented the migration paths of the various communities of Jews in Philadelphia. The branching-out of the Jewish population and the acquisition of inexpensive farmland made it possible to have a ring of Jewish burial grounds placed according to Jewish custom beyond the living quarters of its population. (Courtesy Allen Meyers.)

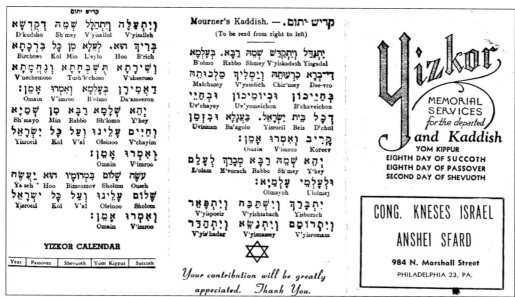

Many Jewish customs take on a communal role. The call to prayer cannot take place without a quorum of 10 people. The three pilgrimage holidays (Succoth, Passover, and Shavoth) that recall travel to Biblical Jerusalem for seasonal celebrations include a community-wide service to remember the deceased. That service, called *Yiskor*, or "remembrance," is held at synagogues, where the entire community is invited to attend. An appeal for funds usually accompanied these services. (Courtesy Burton Friedman.)

Like other families, Jewish families that have moved from one place to another find themselves congregating with relatives, friends, and neighbors at funerals, where they often take group pictures. The concept dates to the 1920s, when Jewish cemeteries offered picnics on it grounds to prospective purchasers of burial sites—this was to encourage visitors at a time when the ride to the country by horse-drawn wagon or omnibus was often a dusty, three-hour journey. The family shown here celebrates the *Yahrzeit* (anniversary) of the passing for Tzina Barg Abramson in the 1930s. (Courtesy Bettyanne Abramson Gray.)

The Levine family is a pillar of Philadelphia's Jewish community and has taken on a great responsibility. The people who are entrusted to ensure the proper burial of the dead also have families to care for and look to many in the community for solace. Leonard Levine (third-generation funeral director), pictured with his wife, Ruth, enjoys a peaceful dinner at the Sheraton Hotel in Tel Aviv in 1967. (Courtesy Joseph Levine.)

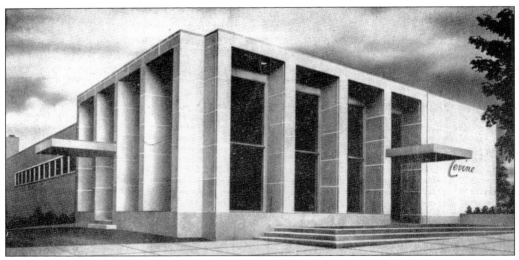

Joseph Levine & Sons has served the community as funeral directors since 1883. Louis Levine founded the South Philadelphia business at 1011 South Fifth Street with a horse-drawn hearse. The next generation, Joseph, and his wife, Bessie, occupied and ran the business from 700 Pine Street. Leonard, a member of the third generation of the family, and his wife, Ruth, led the business at 1500 North Broad Street. Joseph Levine, in the fourth generation, relocated the business to 7112 North Broad Street near the northern city limits. The fifth generation includes Adam, Brian, Jonathan, and Lindsey, who have opened their first suburban funeral chapel on Street Road in Trevose to serve a growing Jewish population in Philadelphia's northeast suburbs. (Courtesy Joseph Levine.)

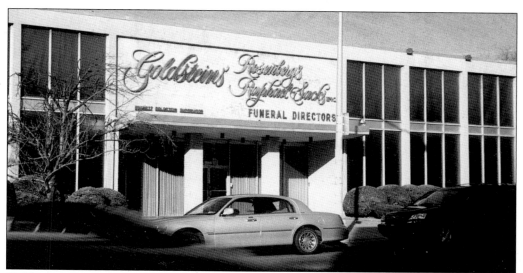

Goldstein's Funeral Directors is well known throughout the Philadelphia and southern New Jersey Jewish communities. Starting out in South Philadelphia, Jack and Joseph Goldstein were motivated by Sameul Dubin, a founder of the Downtown Home for the Jewish Aged at Fifth and Moore Streets. Mourners spilling over onto the small side streets during the services in the late 1930s was seen as a disgrace. The Goldstein family built a memorial chapel in the 1500 block of North Broad Streets. The Goldsteins's then built a large modern funeral home facility, above Chelten Avenue along the 6400 North Broad Street in 1964.

The Goldstein family, who freely entered into a most sacred profession within Judaism, proves that families can do almost anything together, including running a business. That sense of family is the key for success. It does not hurt to have a business planner in the family, either. Ruthie, the daughter of Joseph Goldstein, crafted the business outlines after her graduation from the Temple University program for funeral directors. (Courtesy Goldstein's Funeral Directors.)

Roosevelt Memorial Cemetery's history is of a progressive establishment. In the 1930s, Roosevelt developed the first bronze garden, with benches to allow weary visitors to rest. The addition of community mausoleums in the 1950s and the addition of climate control in the 1960s were practices not duplicated in the region for some time. By the late 1960s, the computer in its earliest stages was in use here. In 2002, David Gordon, the cemetery executive and guardian in many ways, provided Congregation Shivtei Yeshurun (from Fourth and McKean Streets of South Philadelphia) a way to perpetuate its communal existence after it closes its doors one day. The transfer of its artifacts, Torah, and Ark will serve its on-site chapel inside the community mausoleum.

Sam Stillman became an undertaker when he went into business with Sidney Stillman at 2018 North Broad Street. When he retired in the 1990s, Stillman bought a lordship: that of Haccombe of Newton Abbott, of Devonshire, Devon, England. Lord Sam Stillman created a Hebrew crest with the help of three Philadelphia rabbis to satisfy one of the requirements for his nobility as owner of his manor. The Hebrew letters below the crown stand for "with G-d's help." The rose is in honor of his deceased wife, the former Rose Schwartz, and the Hebrew letter to the right is an S for Stillman. The three Hebrew letters at bottom left denote that Sam is a Levite, and the lamp represents Sam belief that "the Lord is the light of man—knowledge." The Hebrew letters at the bottom translate as, "from generation to generation." (Courtesy Lord Sam Stillman.)

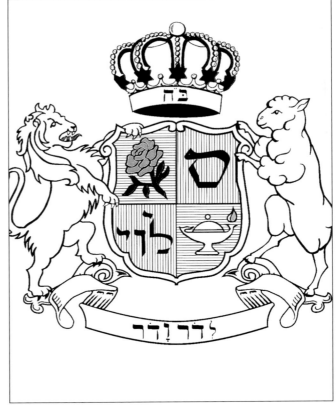

Four

GETTING AROUND
ON THE PTC

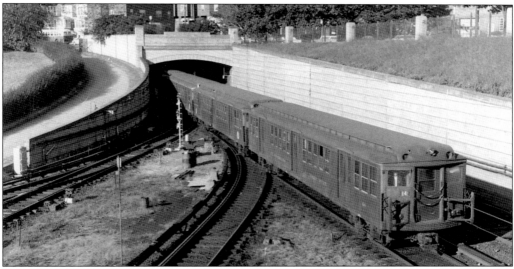

An excellent public transportation system enabled residents to travel to jobs, schools, family, and religious activities with plenty of time to spare. Beginning in the late 1920s, the Philadelphia Transportation Company (PTC) scheduled trolley cars, diesel-powered buses, and trackless trolley buses to intersect with the gem of its system, the North Broad Street subway. The southern division opened below city hall in 1938, and the spine of Philadelphia's northbound and southbound traffic via a modern transportation system made it possible to increase the number of passengers to downtown destinations with less equipment, alleviating the clogging of its streets. Forty-five trolley car lines served the northern section of the city in its heyday in the 1920s. Trolley car routes connected with new North Broad Street subway stations. The net effect of the modernization of the system allowed a growing population in the city more mobility and the freedom to live farther north yet still arrive downtown quickly. (Courtesy Dick Short.)

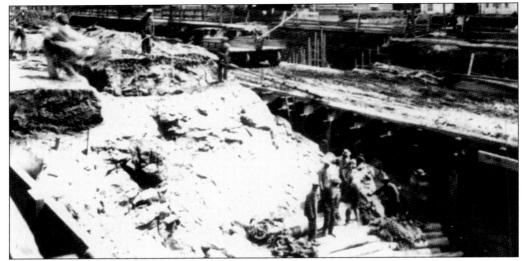

In the 1920s, business was disrupted up and down North Broad Street for six years for the excavation of the subway. Many Jewish people made the trip to their local house of worship on North Broad Street by way of a detour, allowing them to find alternate routes and explore the neighborhoods off Broad Street. After World War I, a housing boom brought new dwellings to places such as Logan and Oak Lane. This photograph was taken at North Broad and Duncannon Streets only several blocks below the Jewish Hospital near North Broad and Olney Avenues in 1924. (Courtesy Philadelphia City Archives.)

The Keystone Construction Company played a major role in the subway construction up North Broad Street. Ben Baskin, its chief engineer, directed its design. The connection of the subway with the Market Street elevated took careful planning, as the lines had to cross under one another many fathoms below city hall. Heavy timbers shored up the multilevel tunnels that had been built from 1922 to 1928. The grading of the terrain northward required more steel beams of varying lengths to prevent vehicle traffic from caving in on the subway. Urban planners, civic groups, and representatives from the prominent synagogues and churches along North Broad Street petitioned city officials to run the high-speed railroad underground so as not to decrease property values with the unsightly iron structure. (Courtesy Debbie Baskin.)

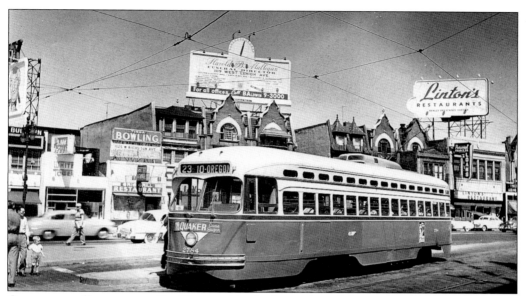

Crosstown trolley car route No. 23 started in the far reaches of Germantown and meandered its way through North Philadelphia en route to South Philadelphia for more than 12 miles, making it one of the longest lines in the city. German Jewish merchants from Germantown and Chelten Avenues could visit relatives in the North Liberties district via one connection. Pictured here is route No. 23 on Germantown Avenue where it intersects with North Broad Street and Erie Avenue. (Courtesy Dick Short.)

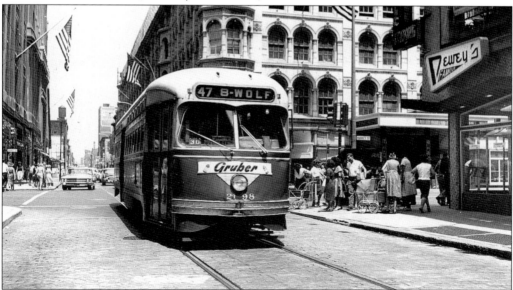

The modern streamlined trolley car fleet produced for the PTC has its origins in St. Louis. Route No. 47 ran on Eighth, Ninth, and Fifth Streets on its way southbound from its terminal at Fifth and Godfrey Avenues in Olney to South Philadelphia. Hundreds of people disembarked at Eighth and Market Streets for shopping trips to the famous Lit Brothers and Gimbel Brothers department store every hour. Mouth-watering treats such as Philadelphia's own soft pretzels and tasty Dewey hamburgers awaited many shoppers as they arrived downtown. (Courtesy Dick Short.)

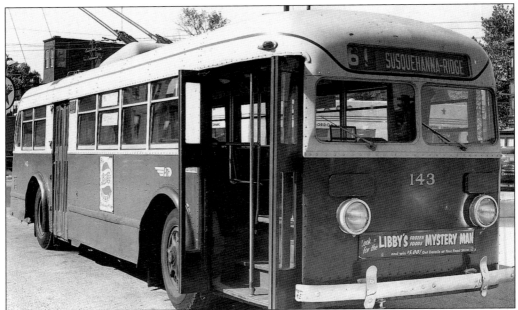

Popular route No. 61 ran along jagged Ridge Avenue from downtown out to beautiful Strawberry Mansion and beyond to Manayunk, which has also supported a small Jewish community since 1888. During World War II, defense workers from the above communities needed a faster way to the Philadelphia Naval Ship Yard at the bottom of Broad Street. The line was converted into the high-speed route No. 61, trackless trolley buses that fed the North Broad Street. (Courtesy Dick Short.)

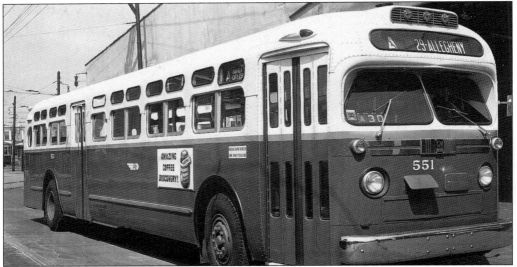

Buses played a major role in transporting large numbers of people beginning in the 1920s. Originally, the route A bus tested only one of several lines that sported the familiar English transportation vehicle, the double-decker bus. The east-west line ran from the steel plants on Hunting Park Avenue westbound along the new Roosevelt Boulevard to the Frankford Market Street Elevated, with a crossover to North Broad Street. All of the buses were painted with the familiar green, white, and orange color scheme. (Courtesy Dick Short.)

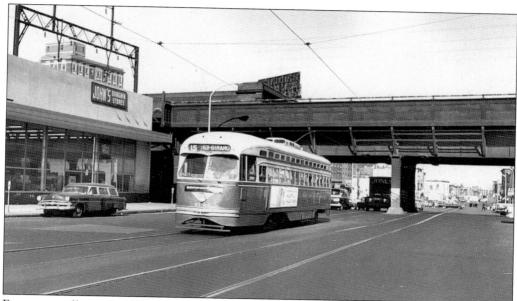

East-west trolley car traffic ran on major streets and crossed many other lines that served North Philadelphia. The Girard Avenue line, beginning 10 blocks north of Market Street, ran from the Delaware River and connected more than six Jewish population centers. The route No. 15 trolley car is pictured heading westbound toward North Broad Street in front of a branch of the popular John's Bargain Stores near 10th Street. (Courtesy Dick Short.)

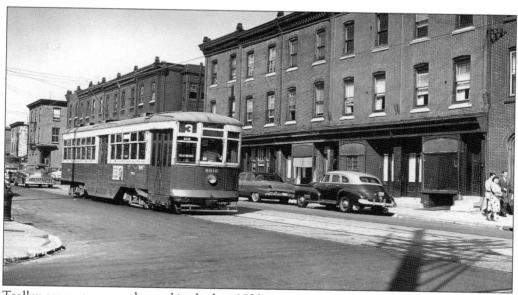

Trolley car routes were changed in the late 1920s to intersect with the new North Broad Street station of the subway. Route No. 3 connected Strawberry Mansion with North Philadelphia via Columbia Avenue eastbound and then ran under the newly built Frankford elevated system, with a terminal at Bridge Street. Local stops were made every block so people who could not climb the steps to board the elevated trains could navigate the city. (Courtesy Dick Short.)

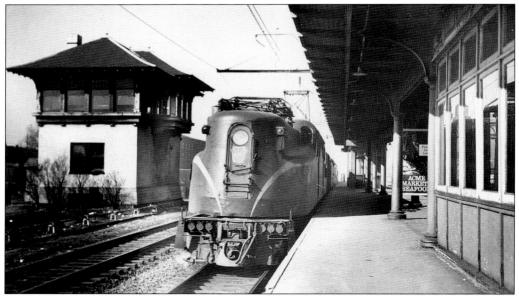

Passenger rail service along the Pennsylvania Railroad system fostered a northern migration path in the early 1900s from areas near its suburban station terminal at 16th Street near Market Street. Several lines ran northward and stopped at the Broad Street Station, where the line crossed Lehigh Avenue and made for a hub of transportation lines meeting on North Broad Street. (Courtesy Dick Short.)

The Reading Railroad served many communities, and all of its passenger lines fed into the Reading Terminal at 13th and Market Streets. Passenger lines such as the Mount Airy Station made it easy to arrive downtown within 20 minutes well relaxed on any weekday. The ride downtown was a favorite among its loyal riders, who sometimes became familiar with the railroad because of wildcat strikes by driver's unions from the Philadelphia Transportation Company. (Courtesy Dick Short.)

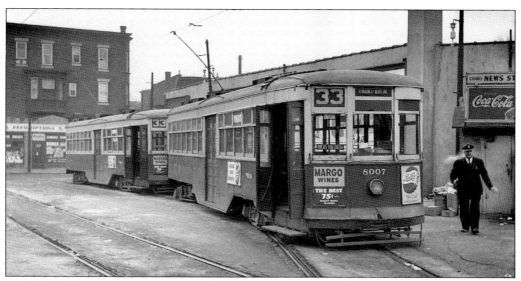

Reliable trolley car service meant trolley cars arriving promptly one right the other every 10 minutes. The journey to school, work, or shopping involved taking Route No. 33, which ran from 23rd and Venago Streets to downtown Philadelphia via North 22nd Street, where Jewish merchants operated stores and where there were many synagogues. Access from the downtown district to Shribe Park, home of the Philadelphia Athletics, alleviated crowded conditions on the subway on Sundays. (Courtesy Dick Short.)

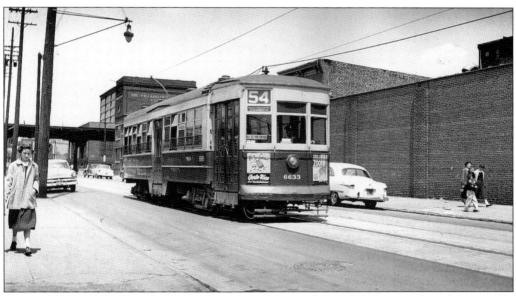

Many of Philadelphia's eastbound and westbound major thoroughfares once shared the middle of the street with both trolley car lines and freight train traffic. Route No. 54 played an important role for sporting events of two major league baseball teams that vied for sellout crowds. Rides to school, however, obtained by hopping on the backs of these trolley cars were strictly prohibited, yet many children still did it. Access to hospitals and industrial complexes made Lehigh Avenue the most crowded street for both pedestrian and vehicle traffic. (Courtesy Dick Short.)

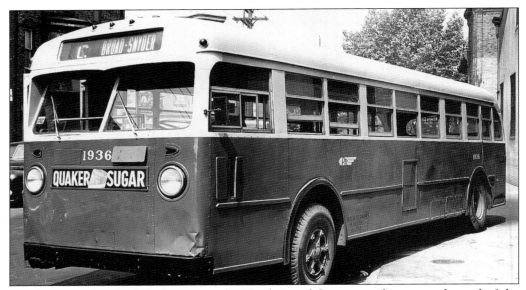

The largest multivehicle hub to serve the North Broad Street corridor was at the end of the North Broad Street subway at Olney Avenue. Trolleys and buses fed into the North Broad Street subway and provided access to the northern suburbs and the Willow Grove amusement park. The North Broad Street and Olney Avenue hub allowed easy access to any section in all four directions fanning out from its center. Known as the C, the line provided an alternative during the excavation of the North Broad Street. The luxury service enjoyed by many Logan residents included door-to-door service from city hall to their homes off Ninth Street above the Roosevelt Boulevard in the 1950s. (Courtesy Dick Short.)

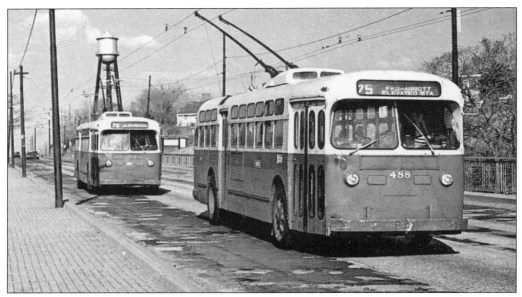

Route No. 75 traveled from Logan, where it made a connection with the North Broad Street subway, to Frankford, where it coupled with the Frankford elevated line. Originally, this popular transportation line served as a trolley car route until the end of World War II, when high-speed trackless trolleys or electric buses came on line. (Courtesy Bob Weiss.)

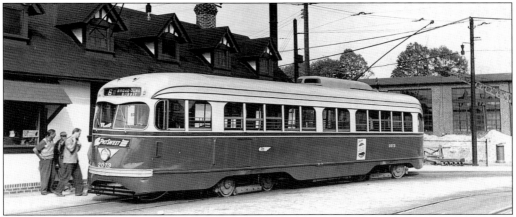

The ability to move mass numbers of people from the suburbs to the city in an hour demonstrated that the daily commute could attract loyal ridership. A new era in Philadelphia's transportation history opened in the northern corridor with a new line that required only one transfer from either Route No. 6 or Route No. 55 interurban ride to Olney Avenue. This provided an easy connection to the North Broad Street subway for the short trip downtown. The open farmlands that surrounded Ogontz Avenue gave way to new housing that encouraged Jewish migration farther north and northwestward during the Great Depression. This lead to a great housing boom in the area after World War II. (Courtesy Dick Short.)

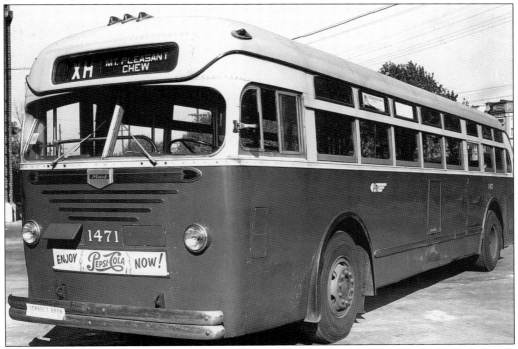

The development of new bus lines before 1940 reinforced the public transportation system with a dependable extension of its world-class trolley car system. The push to the far reaches of the northwest section of Philadelphia in Germantown, where new communities began to spring up, made it feasible to live and work within the city if connected to the North Broad Street subway. (Courtesy Dick Short.)

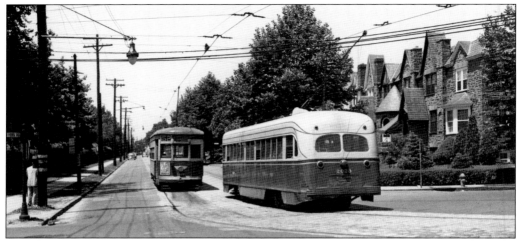

The creation of trolley car Route No. 52 via Chelten Avenue connected two important communities in the north and northwest sections of Philadelphia, from which residents made frequent shopping and leisure trips to points in Germantown. Jewish children who went to the Wagner Junior High School along the route could easily access Germantown High School during the 1940s. A change in the community could be witnessed as the old-fashioned wooden frame trolley cars gave way to the modern steel streamlined ones in the 1950s.

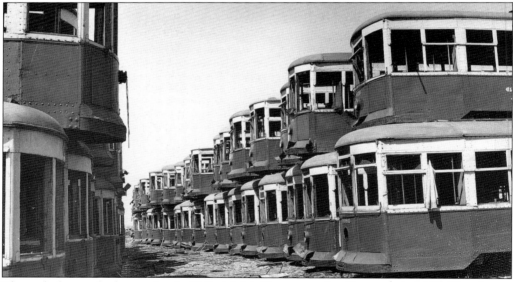

The end of an era had come for the Philadelphia Transportation Company in 1955. The change in neighborhoods due to upward mobility of many Jewish households allowed for the exodus out of specific sections such as Strawberry Mansion and for the discontinuation of the once very popular trolley car Route No. 9 to South Philadelphia. Progress underlined this important crossroad in Philadelphia's transportation history. Rides on these old treasured vehicles conjured memories of the bumpy rides taken from where we came from to our new homes and neighborhoods. The trolleys, and with them the past, were now stockpiled on empty lots deep in South Philadelphia from Seventh to 10th Streets along Packer Avenue. The trolley cars were completely scrapped to make way for the new Walt Whitman Bridge, providing access to New Jersey in the mid-1950s. (Courtesy Dick Short.)

Five

SCHOOLS

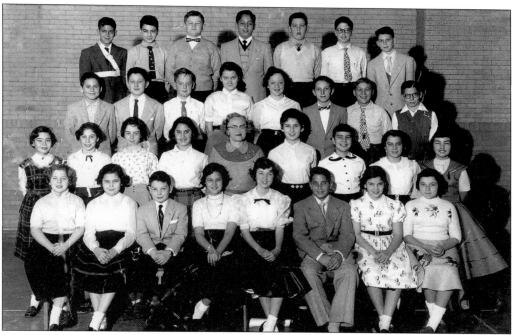

Thousands of children from the surrounding streets in Logan attended the General Davis Birney Elementary School, located at Ninth and Lindley Avenues. The school served two generations of Jewish residents and children from the 1920s until the 1960s. Bobbie Simon Samuels remembers the sunny days when she and her friends played in the large recess yard during and after school. The socialization of Philadelphia's neighborhoods is due in large part to its local schools. Children of all ages came together to learn and establish lifetime friendships. The neighborhood schools also acted as a catalyst for neighborhood pride through identity. A typical question often repeated on the first day of high school—"Where are you from?"—was a defining moment in the lives of many freshmen. School colors and songs that were etched in our collective memories came alive 40 or 50 years later at old school reunions held in fancy hotels or country clubs. (Courtesy Bobbie Simon Samuels.)

Miss Mc Closkey, a teacher at the Birney School for many years, was a favorite first-grade teacher who enjoyed each child as her own. Adults who attended Birney recalled the circle located in the recess yard, where children participated in the exciting show-and-tell programs, giving them their first taste of public speaking. (Courtesy Shirley Meyers Sivitz.)

North Philadelphia had many neighborhoods with indistinguishable boundaries. Children living north of Girard Avenue near Seventh Street had an identity problem only in regards to which street corner intersected near their homes. In addition, the students knew their neighborhood according to the James Ludlow Elementary School at Sixth and Masters Streets. The neighborhood boundaries changed suddenly from one street to another without any warning or knowledge by the children. Aaron Katz, who graduated Ludlow in 1944, had many friends regardless of school boundaries. (Courtesy Aaron Katz.)

Schools were made up of two distinctive groups of children regardless of economic class. The mainstream group of students started out in first grade and went through school until grade six or eight and knew each other outside of school as well. The other group was made up of newcomers who arrived in the community as their parents made a change of address from one section of Philadelphia to another. Jerold Klevin had many classmates who signed his 1949 graduation photograph on the back, including Lynne Felscher, Steve Davidoff, and Carol Abrams. (Courtesy Jerold Klevin.)

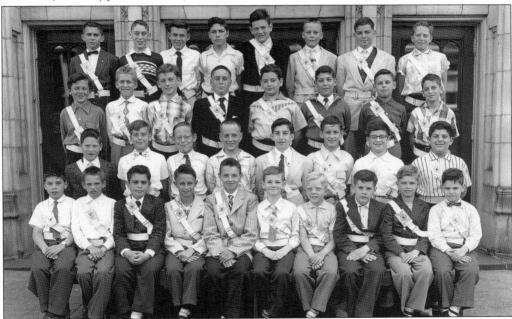

Special status went to the boys who aided in the safe passage of children to and from school. The Safety Patrol became an honor society and open only to those students who had good grades and who were recommended by teachers or other safety officers. Walter Spector recalled the meetings and special award luncheons at the James Kinsey School, located in the West Oak Lane section at 65th Street and Limekiln Pike. The "safeties" were all honor students with attractive white safety belts usually inscribed with three letter As, for their sponsor, the Automobile Association of America. (Courtesy Walter Spector.)

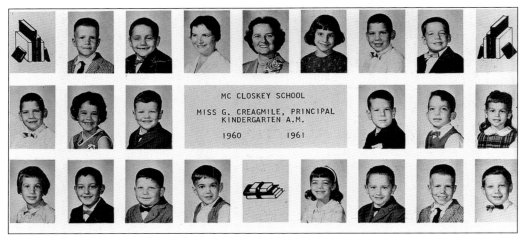

Ellen and Eric Gooseberg attended the John Mc Closkey School at Pickering and Gowen Streets in the upper reaches of West Oak Lane in the early 1960s. The neighborhood, with its many synagogues and schools, remained viable throughout the 1970s with the influx of many Strawberry Mansion transplants with young children. The issue of public school busing to racially balance the classes from outside neighborhoods exploded when beloved teacher and community leader Samson Freedman was murdered on school grounds at the Leed Junior High School. The exodus from West Oak Lane by its large Jewish population gave little hope for a second generation to raise Jewish children in the neighborhood. (Courtesy Stanley Gooseberg.)

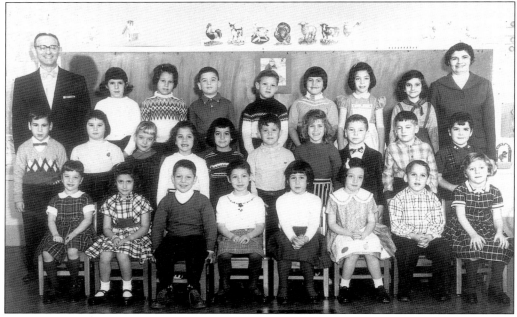

The A.B. (Anna Blakiston) Day School at Crittenden and Johnson Streets served a predominantly Jewish population throughout Mount Airy. Principal Sidney Musicant and teachers such as Frances Zomick made the day go by faster with plenty of arts and crafts for all the children. Many government workers and their families in the 1950s were relieved to find that the area was served by the Reading Railroad. (Courtesy Jay Steinberg.)

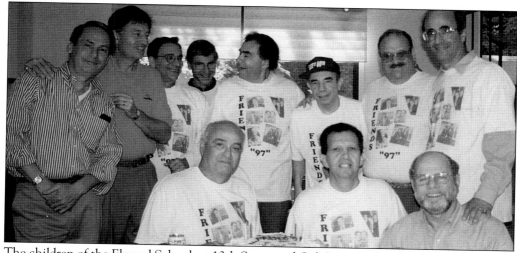

The children of the Elwood School, at 13th Street and Oak Lane, in this photograph were born in 1937 and have traveled together ever since those days. Shown are, from left to right, Lee Weinstraub, Steve Kutten, Aaron Simon, Jerry Klevin, Danny Leder, Jerry Rosenthal, Richard Levine, Lloyd Remick, Bruce Sherr, and Selig "Babe" Smiler, who gathered in 1997 to celebrate 60 years of friendship. Although only some of the boys went to Boy Scout Troop No. 399, they all attended Wagner Junior High School, hung out at Mickey's candy store, and went to the Esquire Theater and the Hot Shoppe restaurant in the 1950s. (Courtesy Lee Weinstraub.)

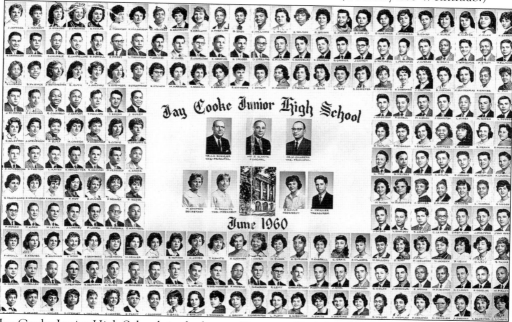

Jay Cooke Junior High School, in the heart of Logan at York Road and Louden Street, attracted many Jewish students after World War II. Changing neighborhoods made it desirable to "fake" your address or claim that you lived with your cousin at a "better" address in order to attend this popular school. The children loved Mr. Burger, who taught Spanish. Logan was a way of life for many who enjoyed the convenience of its many schools, all of which were nearby. (Courtesy Ruth and Sara Mendelsohn.)

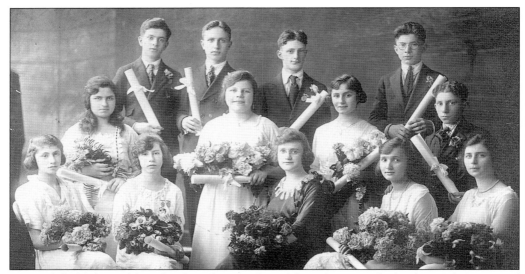

Many Philadelphia public school teachers graduated from the normal school at 13th Street and Spring Garden Avenue. The program was designed to educate young adults right out of high school on the elements of teaching classes in history, English, and other subjects. Many Jewish students had the added advantage of learning the teaching profession through Gratz College's supplemental Hebrew school program. Ada Bandel Meyers graduated from the normal school in 1925, and her initial assignment was to teach first grade at the Hartranft School at Seventh and York Streets, near where she grew up. Finally, after 40 years, an opening at the Birney School in Logan, where then Ada lived, opened up. She accepted the position and walked to her classroom from 4654 north Warnock Street to teach for one year until her passing. (Courtesy Shirley Meyers Sivitz.)

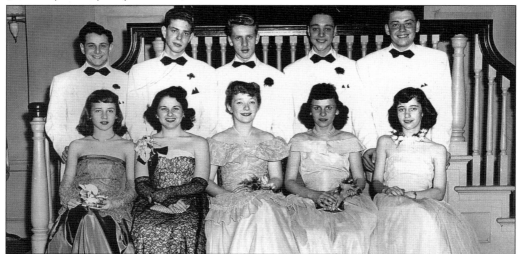

North Philadelphia provided many students seven public high schools from which to choose after graduation from junior high school. Stewart Gruber, from Third and Berks Streets, chose Northeast High School, when it was located at Eighth and Lehigh Avenues. This 1948 senior prom picture includes Stewart Gruber, Bruce Kravitz, Harry Frank, Stan Kramer, Joan Cutler, Doris Baker, Marlene Forman, Charlotte Chasen, and Sydelle Kessler. (Courtesy Stewart Gruber.)

Another great rite of passage in high school came when class officers selected the location of the class trip. The weekend trips were chaperoned by responsible individuals from the community. Hundreds of seniors from Olney High School gave their deposits early to reserve a seat on the chartered excursion via the Reading Railroad to Bear Mountain in upstate New York in 1956. The trips to New York State included cruises up the Hudson River. (Courtesy Arlene Vinikoor.)

OLNEY
HIGH SCHOOL
SENIOR CLASS TRIP
TO
Bear Mountain
NEW YORK

Beautiful Bear Mountain Park

WEDNESDAY, SEPTEMBER 26
1956

VIA

READING RAILWAY SYSTEM
AND THE

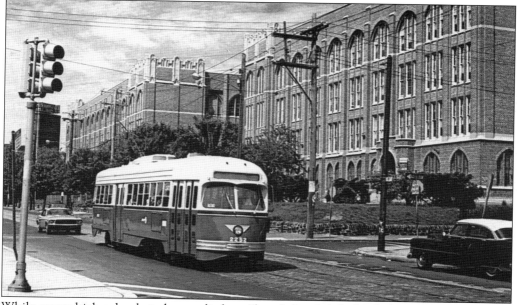

While many high school students relied on "hops" (hitch-hiked rides) or the "shoe leather express" (walking) to travel to and from school, chartered trolleys and buses brought thousands of students to many schools daily. Simon Gratz High School and Elizabeth Gillespie Junior High School, located next to each other at Hunting Park and Pulaski Avenues, attracted many students from the North Broad Street corridor to its campus in the late 1930s. The excellent grid of trolley cars provided a convenient and safe pathway to school. (Courtesy Bob Weiss.)

The Philadelphia High School for Girls, once located at the corner of 17th Street and Spring Garden Avenue, appealed to students from across the city. The business districts where Jewish merchants clustered included Brewerytown, along Girard Avenue and 29th Street, where such stable merchants included Nagelberg Hardware and various drugstores. The daughter of a druggist, Lillian Kaplan, poses with her girlfriend and fellow graduate, Alice Horwald, in 1956. (Courtesy Lil Kaplan Weilerstein.)

The Jewish high school fraternity Sigma Alpha Rho stood for "social, athletic, and religious" ideals. Several chapters were organized in the first decade of the 20th century. Students at the Central High for Boys studied under longtime teacher Adolph Caplan, who moved with the school from Broad Street and Spring Garden Avenue before World War II to its new location at North Broad Street and Olney Avenue. New teachers at the new location included Ronnie Rubin, Steve Noscow, Harris Snoparsky, Steve Weinstein, Dave Rosenfeld, Tommy Roberts, and Joel Weiner. The men met for brunch at Latin Casino downtown one Sunday a month. (Courtesy Dennis Lyons.)

Another Jewish fraternity that attracted junior and high school students formed under the supervision of B'nai Brith as AZA (Alpha Zadok Alpha). Young adults formed the Shield of David chapter in 1953, which united many Jewish children into one group at Wagner Junior High School. The social and athletic events drew many students, who later attended Central, Olney, and Germantown High Schools. Some of the members in 1956 included Don Schwartz, Al Morris, Joel Spivak, Marlene Sadoff, and Elaine Katz. (Courtesy Joel Spivak.)

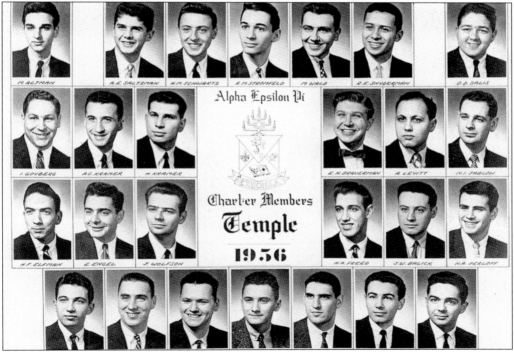

Jewish activities on the campus of Temple University dated to the founding of the Hillel Foundation in the 1920s, organized with help from benefactor Ellis Gimbel. During the 1950s and into the 1960s, thousands of Jewish students attended classes at Temple's many liberal arts programs. The Jewish fraternity Alpha Epsilon Pi, founded in 1956, catered to young men who came from both Philadelphia and other parts of Pennsylvania. (Courtesy Max Wald.)

The emphasis on early childhood education is a well-known tradition in the Philadelphia Jewish community. The Jewish Community Center movement aided this development in communities such as Strawberry Mansion. The push into the new Jewish neighborhoods in Germantown and Mount Airy in the late 1950s found many parents searching for good programs. Miss Marty's preschool at 222 Harvey Street in Germantown catered to children between the ages of three and five years old. Miss Marty previously had run programs at the Finley public playground, located at Mansfield and Upsal Streets in Mount Airy, during the summers before opening her own school in 1964. (Courtesy Lil Weilerstein.)

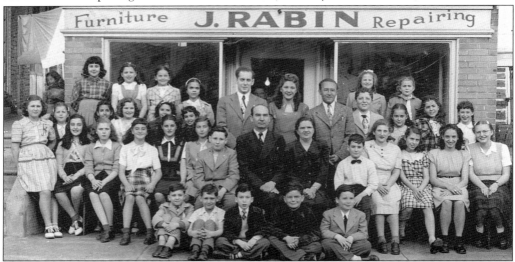

Afternoon religious and secular (Jewish content) education and events abounded in the neighborhoods off North Broad Street in the 1950s. Logan, with a population of 12,000 Jewish residents, supported 12 synagogues and the United Northern Hebrew and nursery school at 10th and Ruscomb Streets. A large number of Holocaust survivors migrated to Logan in the early 1950s, where they set up the Workman's Circle School No. 2 on the premises of Rabin's Furniture. Lessons were given in Yiddish and English. (Courtesy Ruth Melman.)

Six
FAMILY NEIGHBORHOODS

With an influx of European Jews after World War I, new housing in Logan became available, and the first migration out of North Broad Street of earlier residents took place. The availability of shopping, schools, synagogues, social events, and public transportation was a prerequisite for setting up a new Jewish enclave, but a prevailing factor was based on living close to all branches of one's extended family. Housing shortages led to the construction of whole new neighborhoods constructed by A.P. Orleans in the West Oak Lane and Temple Stadium areas and in Mount Airy and West Mount Airy. Jewish families could now live in newly built homes with large lawns and, because of an improving economic status, ride in newly purchased cars. A new outlook on life and an adjustment to new surroundings is evident in this photograph of the Lilenstein family. (Courtesy Flora Lilenstein.)

Jewish people lived in the neighborhood north of Girard Avenue and east of Third Street, where Germantown Avenue came to its terminus. Anshei Sholom congregation prevailed in the 1900 block of Germantown Avenue along with Porto Rico soda and the Dutch Den Donuts, owned by Lillian Schacther's parents, Serena and Itnak, both Hungarian immigrants. Max, their oldest child, is pictured with two siblings, Lilly and Emma. The other siblings were David, Joe, Eleanor, and two others. (Courtesy Lillian Schachter.)

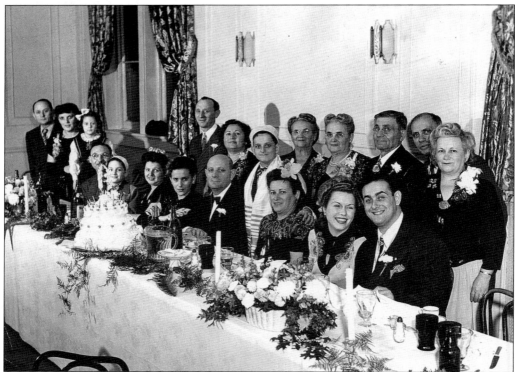

Some people familiar with the Marshall Street business district Minnie and Isadore Barmat, who arrived from Russia in the early 1920s to open a children's wear shop. Blue laws, whereby merchants were not allowed to sell certain items at certain times, did not apply on Marshall Street, unless policeman seemed offended and would then write a ticket. The laws were eased with the help of Councilman Louie Schwartz, who hailed from the community and who sought to see the Phillies play ball on Sundays. This led the way for more relaxed laws. (Courtesy Heshie Barmat.)

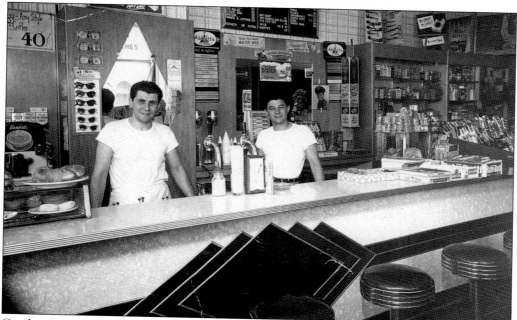

Candy stores with full ice-cream and soda fountains abounded throughout Philadelphia from the late 1890s until the arrival of McDonald's restaurants in the 1950s. Customers came to eat after going to the Diamond movie house at Third and Diamond Streets late at night. Sol and Irv Gruber ran their eatery at Eighth and Norris Streets. (Courtesy Steward Gruber.)

Outings at area restaurants were regular gatherings in the Northern Liberties neighborhood near Seventh Street and Girard Avenue. More than 14 Jewish eateries existed in the community in the post–World War II era. A favorite place to celebrate good times for the Gruber cousins (the Vinitzky, Sunshine, Levitt, Stesis, and Cutler families) was the Capital Restaurant. (Courtesy Stewart Gruber.)

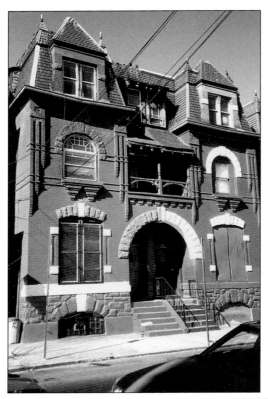

Residents of the German Jewish communities from the 1890s to the 1920s had easy access to the downtown area, neighborhood synagogues along North Broad Street, and the Young Men's Hebrew Association (YMHA) near 16th and Master Streets. Ruth Wolf Kohn recalled the neighborhood around 17th and Jefferson Streets, where the large homes, which looked like mansions, were actually two-family units. (Courtesy Allen Meyers.)

The German Jewish community straddled both sides of North Broad Street even though their places of worship only occupied the east side. The synagogues picked their locations far in advance of their needs as they subscribed to the placement of the *beama,* or stage, facing eastward toward Jerusalem. Meanwhile, many Jewish families took up residence on the 2200 and 2300 block of Park Avenue, nearby. Shown, from left to right, are neighborhood friends Ruth Kohn, Helene Strauss, and Carolyn Samuels. (Courtesy Josie Rosenthal.)

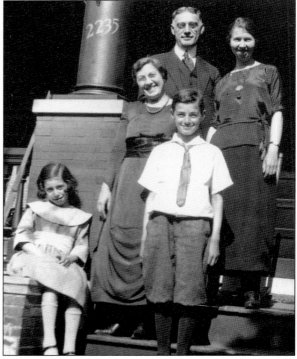

Everyone remembers their best friends growing up as a child. Bobbie Simon played with her next-door playmate, Cheryl Passvannti, at 4645 north Hutchison Street. She lived in Logan, which continued into its second generation of residents and friends when service personnel returned from World War II decided to remain in their boyhood communities. (Courtesy Bobbie Simon Samuels.)

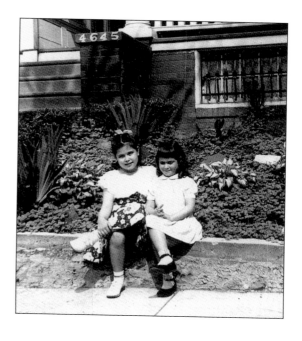

Block parties and other celebrations took place in Logan as in all Jewish neighborhoods around the city during the 1950s and 1960s. Some parties took place on the open porches while such residents as the Strugs, Ginsbergs, and Kalodners gathered at Tankins catering hall just north of Wyoming Avenue to welcome in a new year. Look at those socks that the men are sporting! (Courtesy Ruth Mendelsohn.)

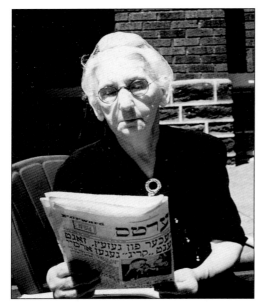

Left: A great spring pastime in Philadelphia's Jewish neighborhoods was sitting outside for the first time after a usual long and harsh winter. Jennie Krouse reviews the news of the day in Philadelphia edition of the *Forverts* on a warm Thursday in 1954. (Courtesy Theodore Krouse.) *Right:* A viable Jewish neighborhood is one where children have many Jewish playmates. In the 1940s, Ted Krause had Sydney Taylor and Stanley Fine to pal around with daily. (Courtesy Ted Krouse.)

Jewish family life abounded in Logan throughout its many blocks with relatives visiting each other for the Jewish Sabbath, rites of passage, and family gatherings. The Machulsky family was in the furniture business in Logan and appeared for a family photograph in Aunt Ann's home in the 1950s. (Courtesy Arlenne Vinikoor.)

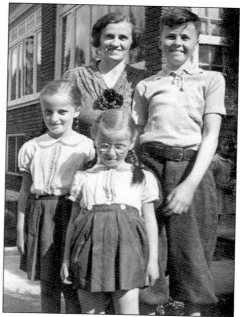

Left: The Caplan family show off the children. Pictured are, from left to right, Gwen and her daughter, Bobbie, on the top landing of their steps in front of their home in the early 1940s. (Courtesy Bobbie Caplan Shaffner.) *Right:* Pride is what neighborhoods are all about, evident in the faces of the Helfand family posed on front of their sun porch at 1730 67th Avenue. (Courtesy Debbie Helfand Baskin.)

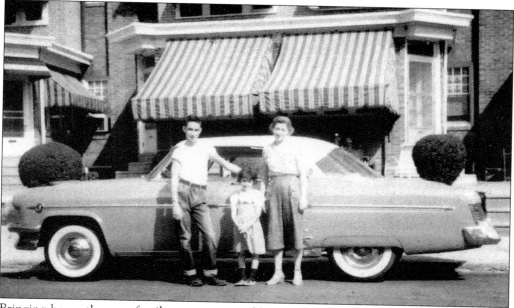

Bringing home the new family car was a neighborhood event. The many car dealerships on North Broad Street included Harold B. Robinson, on 66th Avenue, and Erwin Chevrolet, located at Broad and Champlost Avenues, the Oak Lane section. Pictured in front of a new 1954 Mercury are Joel Spivak his sister Lynn and mother, Helen. (Courtesy Joel Spivak.)

Moving day for the Schwartz family, from West Philadelphia, came in July 1954. Reba and Benjamin dressed up the children and prepared them for a new adventure in life. Reba said to her two sons, Steven and Michael, "You will make new friends and have a safe back yard to play in." The tradition of dressing up on moving day is unique to Jewish people, who took pride in stepping up to the next station in life. (Courtesy Michael Schwartz.)

The farther you traveled into Mount Airy, the larger the lawns and row houses became, yet the homes, and even the cars, all looked alike in the 1950s. That fact did not matter to the children, Ellen Gooseberg and her playmate, Sharon Geboff. (Courtesy Stan Gooseberg.)

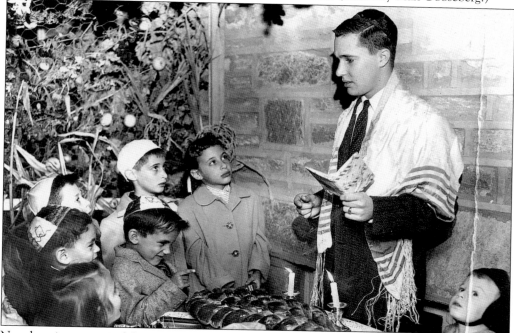

New housing starts in Mount Airy the 1950s provided many Jewish people an opportunity to build a new community full of old institutions such as Bogoslavsky bakery. Phil Remstein, a returning veteran from the Korean War, conducted the harvesttime Jewish holiday of Succoth on his front lawn with the help of his fellow neighbors, all members of Congregation B'nai Jeshurun. The collection of residents from Strawberry Mansion rekindled a sense of community throughout Mount Airy in the late 1950s. (Courtesy Phil and Alan Remstein.)

Many new Jewish families began to form as men returned from World War II. Rabbi Morris Goodblatt married Ruth Tabaal and Herbert Spangler at the Adelphia Roof Garden Hotel at 13th and Chestnut Streets. The wedding, catered by Harry Davis, attracted many people. The couple settled in the new development called Melrose Gardens to raise their three children, Paul, Robin, and Joel. (Courtesy Ruth Spangler.)

Melrose Gardens, a large, new tract of row houses built by A.P. Orleans, provided an instant community for young married Jewish couples who were complete had once been strangers. Similar to the pioneers who had settled Israel, the common bond of their life revolved around family values and provided a large extended family. The community members watched each other's children, hosted dinner parties, went bowling together, enjoyed Pauline and Eddie's ice-cream parlor, shopped at the new Penn Fruit supermarket, and went to the Melrose B'nai Israel synagogue on Cheltenham Avenue. (Courtesy Allen Meyers.)

Seven
JEWISH UNIFORMED
PERSONNEL

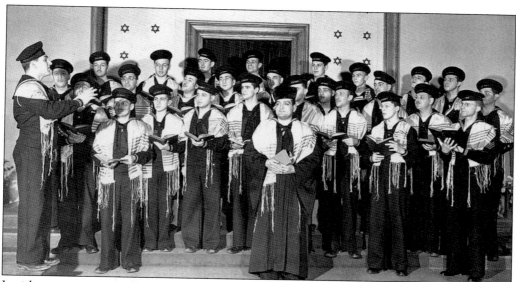

Jewish communities pull together to support their members during times of war. Jews from Philadelphia's northern neighborhoods served in all branches of the armed forces during World War II and the Korean War. On the home front, George Helfand, the son of Russian parents, realized his duty to his country when America was attacked by the Japanese on December 7, 1941. He dedicated the entire window display of his five-and-dime store to pay tribute to the residents of his North Philadelphia neighborhood who had immediately enlisted in the military. The store became an information center and post office during the war. In the past and in more recent times, Philadelphia residents, like all Americans, respond to their country and countrymen in need whenever America is under attack. This chapter is dedicated to the heroic men and women who defended our country after the devastating events of September 11, 2001. (Courtesy Debbie Helfand Baskin.)

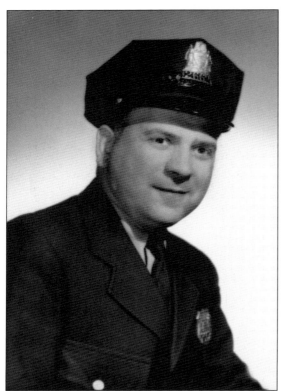

Jewish men took jobs on the Philadelphia police force in record numbers during the 1930s, when jobs were scarce. Nathan Mendelsohn, the husband of Rose (Auerbach), joined the police force in 1945, when the family lived in Strawberry Mansion. Rose often worried about her husband even as the couple moved to Logan. Nathan served as an officer for 20 years. (Courtesy Ruth and Sara Mendelsohn.)

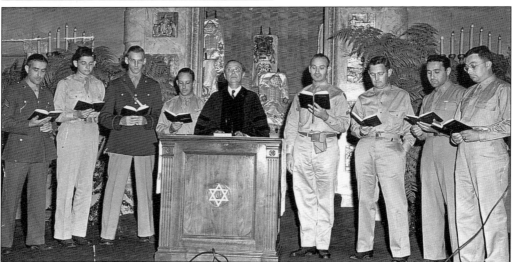

Rabbi Fineshriber from Reform Congregation Keneseth Israel conducted prayer services weekly with service personnel from all arms of the U.S. military during World War II before their departure to their assigned military installation. Those Sabbath prayer services were attended by hundreds of congregants who often came to see their favorite son, father, brother, or uncle on the stage; but they attended with great trepidation, knowing that it might be the last time they would be together. The sermons by the rabbi often helped many families to wait out the war until their loved ones came home. (Courtesy Keneseth Israel Archives.)

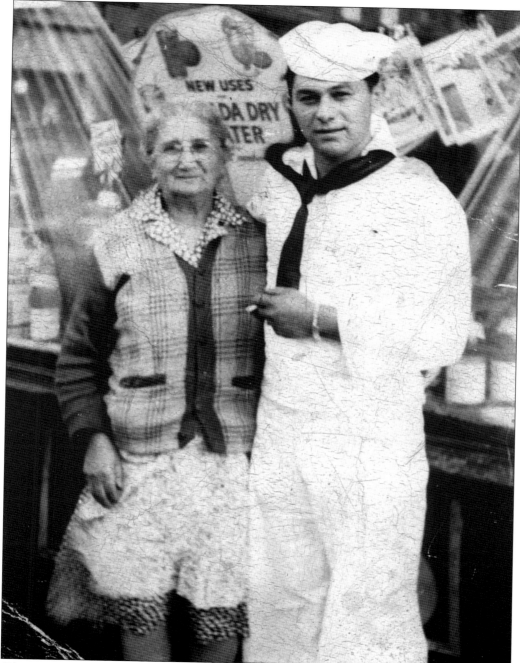

Often, Jewish service personnel went off to war only with memories of their lives in the neighborhoods they loved. Sol Gruber, who served in the U.S. Navy, had a photograph of his Bubbie, Pearl Weisman, taken in front his candy store at Eighth and Norris Streets to comfort him in times of pain and sorrow. For a Jewish person, one's sense of community can travel from place to place, helping them to feel right at home when far away and among strangers. (Courtesy Stewart Gruber.)

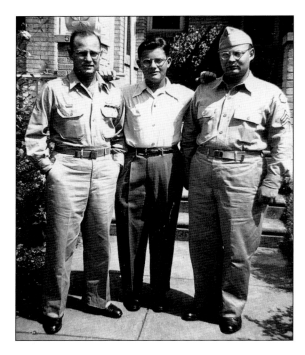

The London boys from West Oak Lane were proud to serve their country. Civilians would often share their trolley car rides with men in uniform, who then transferred to the North Broad Street subway to meet the troop trains that pulled into the North Philadelphia Station and left for far-off destinations along the eastern seaboard. (Courtesy Matt London.)

Joel Spivak and his friend Mel Gelman sat in the cafeteria on Temple University's Cheltenham campus in the early 1950s and decided to enlist in the U.S. Army reserves during the Korean War. These noteworthy students endured basic training in Fort Knox, Kentucky, and proved the 1950s motto "All you need in life is a high school diploma and an honorable discharge from the service." (Courtesy Joel Spivak.)

Uniformed Jewish officers returning home after World War II made up for lost time. Lt. Harry Galinsky missed his usual Sunday afternoon outings to Fairmount Park. The outings were begun anew upon his return from service, offering great hope for a return to a normal, enjoyable life at home. (Courtesy Beatrice Galinsky.)

Enlistments into the various service branches continued after World War II. David Baron enlisted from Logan right out of high school at the age of 17 and arrived in Germany in 1948. The two-year tour of duty included many patrols with David's favorite personal transportation vehicle—the basic-issue army jeep. (Courtesy Dave Baron.)

North Philadelphia resident Stewart Gruber enlisted in the U.S. Air Force in 1949. Little did he know that the Korean War loomed in the near future. (Courtesy Stewart Gruber.)

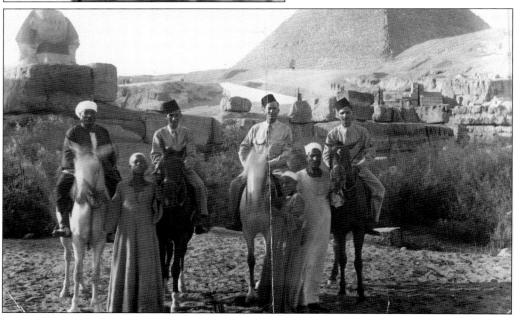

The promise of the armed services to see the world came true for U.S. Air Force flyer John Machulsky, who hailed from Logan. John is pictured fourth from the right with his U.S. Air Force–issued uniform and a Turkish hat as he is being given tour of the Egyptian pyramids in the late 1940s. (Courtesy Arlene Vinikoor.)

Jewish people served in the Vietnam War during the 1960s. Jay Sivitz from Logan did his residency at the Albert Einstein Medical Center in the early 1960s. The military had a deal for students to finish their education without the threat of being drafted. The commitment sealed a person's life for the next two years. Dr. Sivitz served his duty at Selfridge Air Force Base in Mount Clemen, Michigan. (Courtesy Shirley Sivitz.)

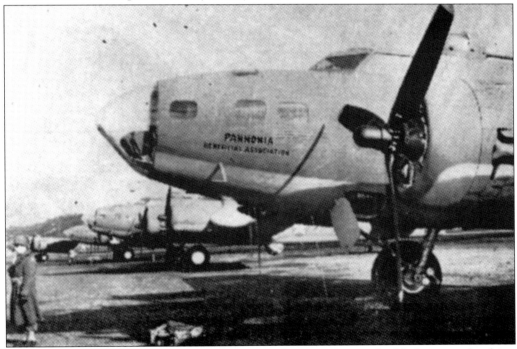

World War II provided many organizations a real opportunity to build their memberships. Some organizations—such as the Pannonia Beneficial Association, which touted 9,000 members—joined in the war effort by raising community funds to purchase war bonds. Their heroic efforts paid off when the organization became recognized for underwriting a B-29 fighter bomber, complete with their name on it. (Courtesy Pannonia Beneficial Association.)

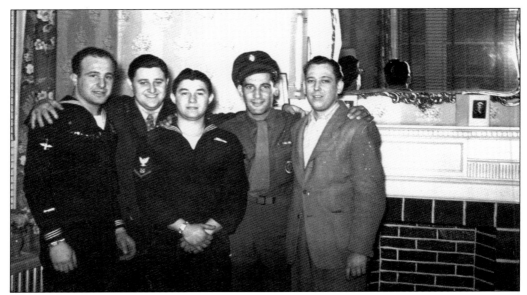

Coming home on leave created quite a stir in the neighborhood for Sol Gruber. Old boyhood friends cherished the moment when they were united for even only a short period during World War II. This remarkable scene captures Abe Schwartz, Sol Gruber, Sol Vinitzky, and Meyer Wasserman, all from different branches of the U.S. military, together once again before they shipped out for combat overseas. (Courtesy Stewart Gruber.)

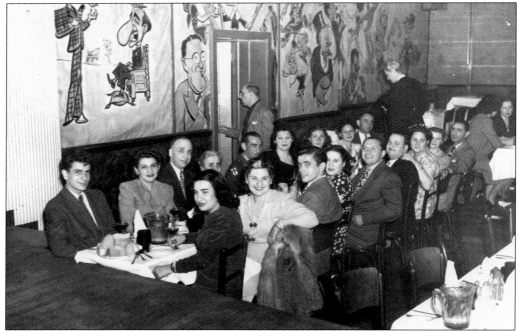

The welcome home celebrations for returning veterans usually lasted for 30 days. The family of U.S. Air Force flyer John Machulsky from Logan held a family affair similar to a wedding at the Latin Casino restaurant off 13th and Walnut Streets in September 1945. The war was over, and John had returned to the family furniture business. (Courtesy Arlene Vinikoor.)

Eight

THE BUSINESS DISTRICTS

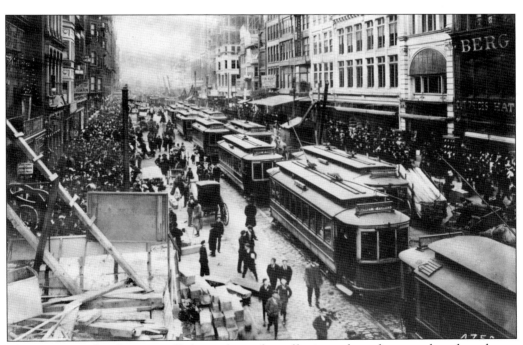

The many varied and strategically located corridors of business throughout north and northwest Philadelphia are tributes to the fortitude of the Jewish merchants who acted as small businessmen. The growing Jewish merchant class selected many major intersections at which to live while raising their children above their stores. This gave rise to small Jewish communities of 10 to 20 families that complemented each other for a variety of goods available to the general public. In the heart of William Penn's great metropolis, at the foot of Market Street, only steps away from the Delaware River, commerce found an instant address in the early 1900s. Large Jewish-owned and operated businesses lined Market Street from Delaware Avenue west to Eighth Street, which included many clothing outlets such as the Berg Brothers, the Hill Company, and the Eagle Shirt Company. (Courtesy Josie Rosenthal.)

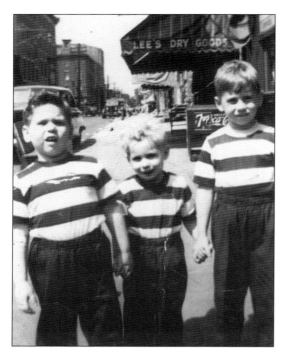

The "bumble bee kids," as they were known on North Marshall Street, were actually a group of Mark Ginsberg's friends who went from store to store, looking for fun while their parents were working. Mark's grandfather, Meyer Soliteran, made cloth-covered buttons; another relative opened a barbershop, and his grandmother sold delicious herring in the 1930s. (Courtesy Mark Ginsberg.)

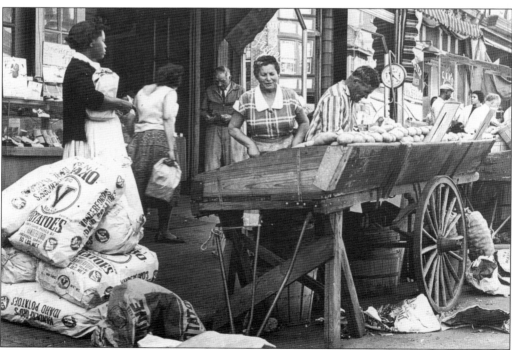

Each merchant was unique and many sold similar products, except for the "potato man," Louis Paul, assisted by his wife, Tella. Pushcarts lined this street of 100 Jewish merchants during most of the 20th century until the 1960s. (Courtesy Urban Archives, Temple University.)

Proprietors of a great tradition in Philadelphia, the Mummers consisted of many working people from South Philadelphia. Each year, they welcomed in the new year with costume, comic, and music as they marched from their homes along Second Street and Synder Avenue up South Broad Street to the judging stands before city hall. The promenade continued along North Broad Street for another 10 blocks to Girard Avenue and then turned right. The North Marshall Street Business Men's Association cherished the Mummers who paraded past their community and presented them with cash prizes for their best acts. (Courtesy Mark Malmed.)

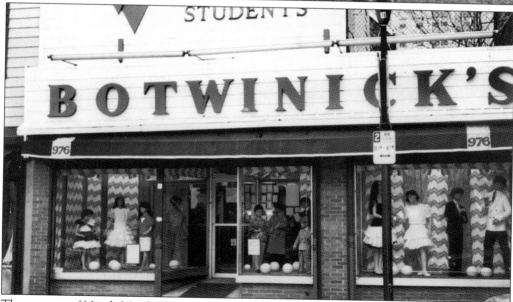

The essence of North Marshall Street came to rest in the hands of the Botwinick's, proprietors of men's, boys', and women's fashions since the early 20th century. Some 50 years later, the city decided to claim this area as "a redevelopment zone" in conjunction with modern improvements to the inner-city merchant's areas. The second generation of merchants refused to surrender their businesses; instead, they modernized them at Jerry Botwinick's encouraging. Late in the 20th century, the Botwinicks saw the redevelopment of their community as an experiment that came and went without any lasting results. Their store moved to Jenkintown in 1991. (Courtesy Jerry Botwinick.)

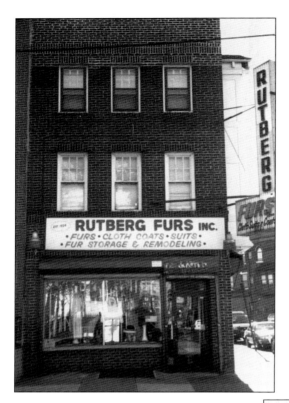

Some stores stay put in one location forever. The Rutberg Fur Company remains open today as a testament of time and its commitment to quality and service for its products. It is located on Girard Avenue near 18th Street.

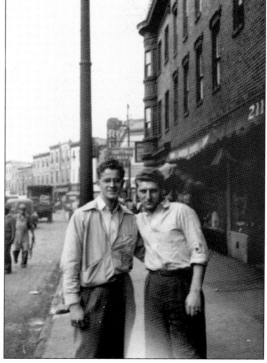

The 22nd Street and Ridge Avenue business district once flourished with 10 meat markets and the Manusov self-service market. Simon Sheinson poses in front of his store at 2117 Ridge Avenue with his friend Eddie Markman. (Courtesy Si Sheinson.)

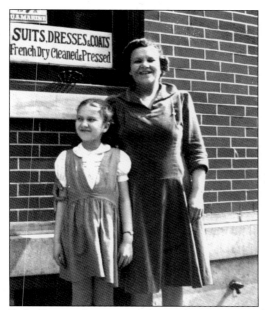

Left: Practical necessity dictated operating a business out of your home in the 1930s at the height of the Great Depression. Meyer Tankel worked out of his home at 957 North Sixth Street while his wife, Rose, and daughter, Mindy, ran the French dry cleaners. (Courtesy Mindy Tankel Blickman.) *Right:* The North Fifth Street Business Men's Association included Sam and Sarah Schaff's, a women's clothing store at 2904 north Fifth Street above Lehigh. A remodeled storefront in 1948 is proof of the good economic times. (Courtesy Jerry Schaff.)

The Germantown and Lehigh Avenue business district attracted a large number of Jewish merchants who engaged in furniture (Lamm & Stern), children's wear (Kingsdorf), the famous Sun Ray drugstore chain and Neven's Drugs, and Cohen's Ladies Wear. Some 50 Jewish merchants made up this bustling shopping district where trolley car route No. 23 ran north and south, intersecting with Route No. 54. The public institutions included a library and the familiar old Northeast High School only several blocks east of the shopping district. Today, Leo's dominates the neighborhood. The business is owned by the Rosenbergs, survivors of the Holocaust. (Courtesy Allen Meyers.)

Left: Traveling east of North Broad Street in the shadows of Connie Mack Stadium and Dobbins Vocational High School on North 22nd Street, 60 Jewish families lived above their stores from the 1920s until the early 1950s. Phil Rosen delivered Jewish newspapers to 80 homes in the area while his parents ran the family cut-rate and variety store. *Right:* Today, more than 40 years since Jewish people lived in Strawberry Mansion, beloved Jewish merchants Harry and Rosalie Siegel maintain their True Value hardware store on Ridge Avenue north of 29th Street.

A Manayunk tradition of terrific furniture for any household is found in the Propper Brothers Furniture, in continuous operation since 1888. The community north of Strawberry Mansion farther along the Schuylkill River and the Manayunk Canal was settled by Russian and Hungarian immigrants. The business catered to a large group of people who lived nearby. The Jewish merchants supported a community center and Hebrew school, the Ivy Ridge Jewish Community Center. (Courtesy Sam Kroungold.)

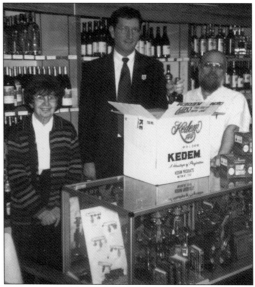

Left: Sack's Jewelry, originally from Marshall and Poplar Street, moved to Logan in the 1950s, and then, recently, to York Road in Jenkintown. *Right:* Rosenberg's Hebrew Book Store, founded after World War II in a home in Logan, quickly expanded to 4939 North Broad Street. Several other religious articles stores in the northern section of Philadelphia included Teller's, at 900 North Fifth Street, and Malmed's Hebrew Books, on Ogontz Avenue.

The Logan lineup of stores included the Logan Electric Shop, founded by Nate and Lenore Shore in 1941 at 4915 North Broad Street. The "wonderful world of lighting" advertising gimmick included a real wooden bridge similar to the ones used in the film *The Wizard of Oz.* Many families and businesses bought their simple lighting and even crystal chandeliers from the store. That long list included the Blackman beauty suppliers, Bernstein dresses, Ryder dresses, Phil Stupp the furrier, Logan hardware, the Asis restaurant, Bob's paint shop, Sack's Jewelry, Rosenberg's Hebrew Book Store, and the Toddle House restaurant. (Courtesy Ivy Shore; longtime employee Willie Nimmons found the photograph.)

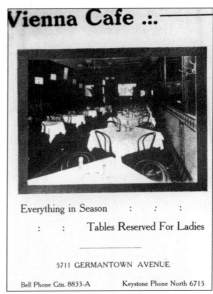

Vienna Cafe .:.

Everything in Season : : :

: : Tables Reserved For Ladies

5711 GERMANTOWN AVENUE

Bell Phone Gtn. 8833-A Keystone Phone North 6715

Left: Germantown and Chelten Avenue Jewish merchants had former ties to Strawberry Mansion, as did many other merchants who sought a new address in the northwest section of Philadelphia during the late 1920s, such as Joseph and Dorothy White Stern, who owned several shops in the area. *Right:* Schweriners stores in the Germantown and Chelten Avenues business district, near the Vernon park square, was successfully operated by hardworking brothers Adolph and Herman, who specialized in shoes and clothing in separate shops at 5723–25 Main Street. (Courtesy Claire Schweriner.)

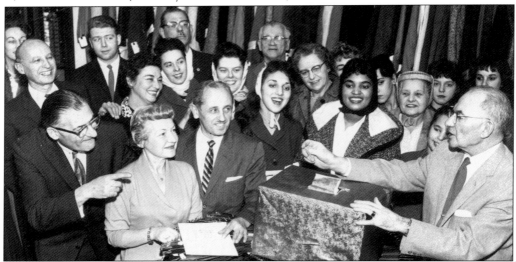

Vernon's Menswear, at 5801 and 5614 Germantown Avenue, appealed to all residents who lived at the intersection of Chelten Avenue. They especially appreciated a raffle of free clothing in 1960. Family members involved in running the business included Aunt Edith, Uncle Joe Cohen, Charlotte and Murray Cohen, and Louis and Elsie Wexler. The area merchants also included Escort Antiques, Pincus Brothers appliances, Wilf Brother's Carpets, Feldencrest furniture, Shirley's dresses, Harrison Cleaners, Alide Hardware, Chain's drugstore, and Ascher candies. (Courtesy Andrea Cohen Breslow.)

Left: Brown's Linens was founded by Abe Brabinsky and his son, Wilbert. They joined other retail outlets that included Linton's restaurant, Dairy-Maid candies, and the Esquire drugstore and movie theater in the late 1930s. *Right:* Leopold Helfand worked his way through pharmaceutical school and opened his drugstore in East Oak Lane at North Broad Street and Chelten Avenue during the Great Depression. (Courtesy Debbie Helfand Baskin.)

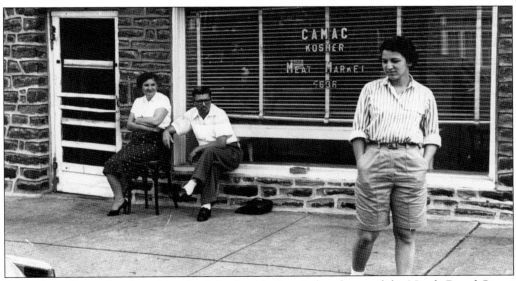

A residential area developed north of the Jewish Hospital and east of the North Broad Street and Olney Avenue after the completion of the subway and terminal in the mid-1920s. A large Jewish population supported the Yagdil Torah synagogue at 5701 North 13th Street and Camac Kosher Meats at the corner of Camac and Chew Avenues, operated by Samuel and Esther Axelrod. (Courtesy Marian Axelrod Kazan.)

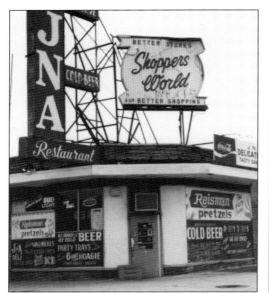

Left: The Wadsworth Avenue business district, laid out by builder A.P. Orleans in the late 1940s, included retail space for 60 stores in a strip mall. Jack's Delicatessen joined Harris drugstore, Artie's, Brown's Linens, Decovney Kosher Meats, Sobel Shoes, and the Chase Bank. *Right:* Moe Stein and his wife, Sally, were both orphans from South Philadelphia. The couple owned the Fruit Basket and fish store in the early 1950s on Wadsworth Avenue. Their business neighbors included Wallace Kosher Meats, Big Bill's Hoagies, Rita Charles hairdresser, Pellman's drugstore, and Stan's shoe repairs. (Courtesy Neil Stein and Dana Bank.)

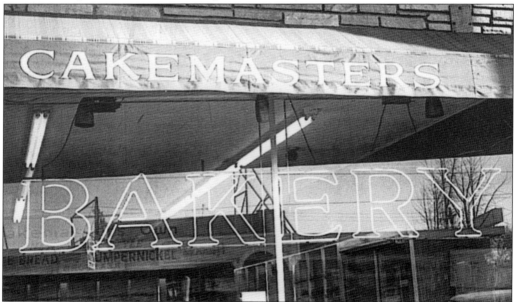

Cakemasters Bakery, known for its cheese knishes, cinnamon buns, and danish, anchored the shopping district. This business district served the growing population north of the Temple Stadium area along Cheltenham Avenue, which began to develop after World War II. (Courtesy Susan Baliban.)

Nine

PLACES TO GO AND THINGS TO DO

At one time in America, there was a slower pace and era, when each person would plan one leisure excursion at a time and took time to enjoy it. The necessity of being in constant contact with work and the demands of having to be in more than one place at a time did not exist. Leisure events took all afternoon, all day, or sometimes all weekend, without interruption. In Philadelphia, families often spent an entire day together in the city, their day full of shopping, sporting events, and food. Philadelphians for generations could come downtown to shop at Gimbels, Lits, Sterns, Strawbridges, Wanamakers, and other well-known department stores, then step into a warm and friendly self-service cafeteria, such as the familiar Horn & Hardart's automat, with all the noises, voices, dishes crashing onto the floor, and coins dropping into the coin holder. (Courtesy Urban Archives, Temple University.)

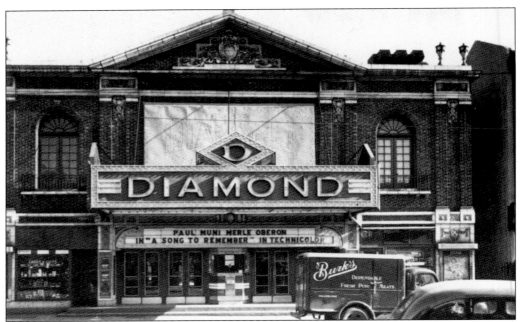

The Diamond movie theater attracted hundreds of children and adults to its air-conditioned facility in the 2000 block of Germantown Avenue. On Saturday afternoons, everyone enjoyed the cowboy serials, cartoons, newsreels, and the main attraction. (Courtesy Bill Goldstein and Irv Glazer.)

Restaurants abounded in the center of town, with many that catered to the patrons of the arts and theater. Ticket holders at the Arch Street Yiddish Theatre (Seventh and Arch Streets) enjoyed an early dinner at Shoyer's restaurant, a landmark for decades at 412 Arch Street. The icon combined fine dining—complete with white linen tablecloths—with a touch of the prevailing corner luncheonette atmosphere—with its counter and ice-cream delights. (Courtesy Walter Spector.)

The post–World War II generation allowed hundreds of Jewish children to inundate the hottest place in West Oak Lane every weekend. Favorite places to visit included the Esquire on North Broad Street above Olney Avenue, the Bromley Theatre on Ogontz Avenue, the Erlen Theatre on Cheltenham Avenue, the Wagner Ballroom, and the great gathering of many teenagers, the parking lot of the Howard Johnson's up Stenton Avenue and Washington Lane. (Courtesy Joel Spivak.)

In the late 1940s, Jewish young adults found the synagogues a haven for social activities through the aegis of the Young People's League (YPL). The YPL hosted many lectures on Friday nights and dances on Sunday nights. After a date at the local movie theaters, young moviegoers would jump into their cars and head for the famous Hot Shoppe drive-in restaurant, which featured curbside service. In the 1960s, the Hot Shoppe moved across North Broad Street from the Godrey Avenue side to the Stenton Avenue side of North Broad Street, the dividing line between East and West Oak Lane, signaling the end of an era. (Courtesy Joel Spivak.)

Jack Emas, an athlete from Logan, turned his love of sports into a job. His father, Rubin Emas, made luggage during the day and headed the usher's union at West Philly's premier sports venue, the convention center and the arena. He inspired his son Jack to play handball. National tournaments took place around the sport. Games took place at the YMHA at Broad and Pine Streets and at the Philadelphia Athletic Club on North Broad and Vine Streets. Even though he wanted to be a boxer, Emas remained with the sport his father encouraged him to play, ranking in the top 10 of nationally recognized handball players in the 1950s. (Courtesy David Emas.)

Part of growing up involves winning and losing various games with friends in the neighborhood. The "bull nose" steps that led to many homes in Philadelphia's neighborhoods became a playground. Balls made of soft rubber, sold at the candy store for mere pennies, were used to play "wireball" against the steps—that is, until the police came around complaining of the noise, at which point you moved to the candy store for the duration of the evening. "First come, first play" was the only rule observed when you hung out inside the candy store and played pinball on the same nickel all night long. The way you grew up had nothing to do with your family's status in the community, only the desire to join in friendly childhood games and pucker up a nickel on the pinball machine to reserve a game. (Courtesy Marc Polish.)

The inside of the Mount Airy Jewish Community Center on Johnson and Arleigh Streets was a great to place to play basketball in the 1950s. Coach Izzy Staler ensured his players all worked together. Those teammates included Randy Cohen, Jay Fagen, Robbie Gold, Steve Brenner, Randy Brister, Jay Steinberg, Harry Bloch, and David Sitman. (Courtesy Jay Steinberg.)

This team, the Logan chapter of the high school fraternal association Alpha Zadok Alpha, is shown sporting their team t-shirts just after they had won the city championship for 1947–1948. Shown are, from left to right, the following: (front row) Stan Lipoff, Marty Jacobs, and Harold Goldberg; (back row) Neil Lazar, Herb Segal, Sheldon Adler, Ned Hammer, Dave Baron, and Jerry Taitleman. All attended Olney and Central High School. (Courtesy Marty Jacobs and Neddy Hoffman.)

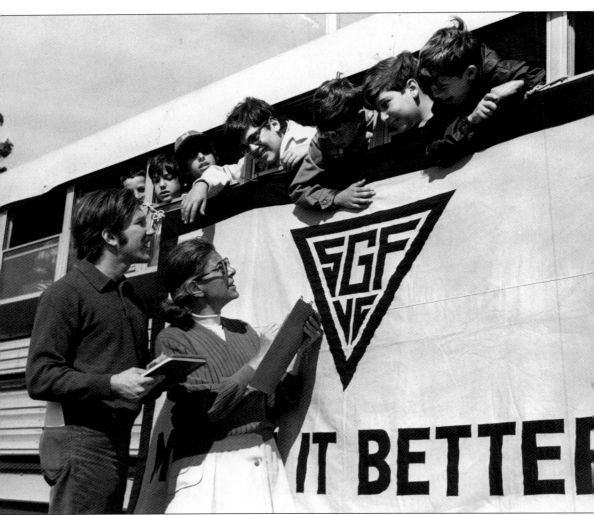

Camp time for urban youth created special bonds among young children. Samuel G. Friedman, a respected leader in the community, created a summer haven for boys in Wood Rock, near Norristown. The vacation camp gave hope to parents who sent their children off to have a great time and "break the apron strings" for the first time in their lives. The girls from Philadelphia neighborhoods were paired up with buddies at Friedman's sister camp, Camp Council. The experience allowed all children to have freedom and assert responsibility in their lives for two weeks out of the year. Mothers could not wait for their vacation to begin either. (Courtesy Mark Melamed.)

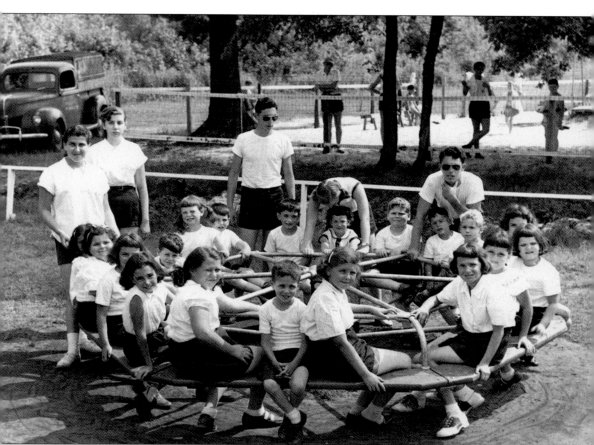

Philadelphia's convenient proximity to the Pocono Mountains and the Jersey Shore provided a great escape for children and adults in the summertime. Lakes abounded in New Jersey, and Jewish settlements provided excellent grounds for camp. An original Jewish settlement, founded in the early 20th century as a seasonal community, was called Jewtown. Located in Burlington County only 25 miles from Philadelphia in the woods of Mount Laurel, New Jersey, it served as a retreat in the country for many Jewish people from the city during the 1920s until the early 1960s. Marshall Street merchants Emil and Mary Ginsberg sent their children, Stanley, Mark, and Ivan, to the camp, which was run by their friends, Herb and Millie Betchen. (Courtesy Mark Ginsburg.)

In the 1930s, Atlantic City was called the Lungs of Philadelphia. The seaside resort was only a few hours from the city by train or car. Wonderful times spent in Atlantic City's Inlet section are recalled by this picture taken at Steele Pier of Stanley Bandel, pictured with Pete, the dog from *Our Gang* fame. (Courtesy Shirley Meyers Sivitz.)

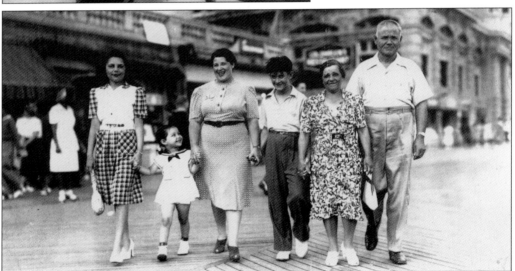

Many people have photographs of their complete family on the boardwalk in Atlantic City, photographs that are considered priceless heirlooms. In this 1941 photograph of Bobbie Simon's family are, from left to right, Bobbie's mother, Sylvia; sister Esther; aunt Dorothy Herman; uncle Bernard Herman; grandmother Fannie; and grandfather Abe Simon. Probably Bobbie's father took the photograph. The old Kodak Brownie-box Six took reliable black-and-white photographs, which were often developed at the famous Sun Ray Drugstores. (Courtesy Bobbie Simon Samuels.)

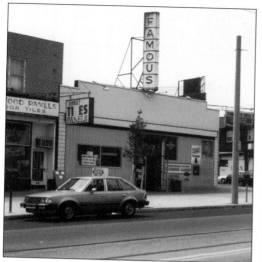

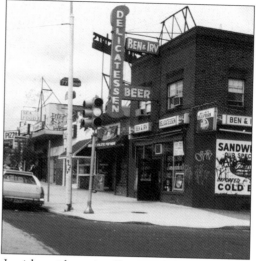

Left: Great delicatessens met the needs of many Jewish residents in all parts of the city. There is only one "famous" delicatessen in Philadelphia, founded by Sam Auspitz in 1923. Called the Famous Delicatessen, it is legendary throughout Philadelphia and known for quality, freshly sliced corn beef. *Right:* Competition is good for all businesses, especially in the West Oak Lane section of northwest Philadelphia, where Ben and Irv's opened a delicatessen on the other side of Ogontz Avenue, only a block away from the Famous. Cold beer seemed to be everyone's favorite on a hot Saturday night. Both delicatessens closed in the early 1980s.

Lee's Hoagie House, a favorite sandwich shop for many Jewish and non-Jewish people since 1953, originated in Philadelphia. Lee and Lillian Seitchik began making their famously large sandwiches, filled with various cold cuts and cheese, lettuce, tomato, sweet onions, along with a secret oil-and-vinegar mixture. The term *hoagie* came into vogue when day laborers packed large sandwiches to take to the Hog Island shipyard during World War II. The original store at 19th Street and Cheltenham Avenue is still open today and is owned by a loyal longtime worker.

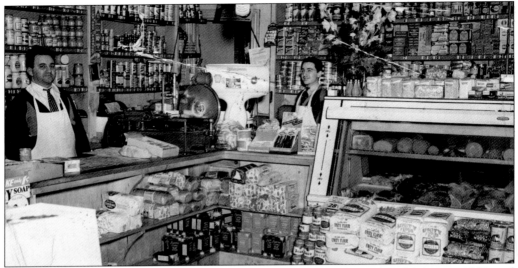

Morris and Jessie Goldstein of Baltimore, Maryland, migrated to Philadelphia in 1929 and opened a full-service meat and grocery market. This mom-and-pop store employed their son William (right) along with his father (left) until 1945 at 310 Diamond Street. (Courtesy William Goldstein.)

After World War II, the decline of corner mom-and-pop food stores gave way to a new method of bringing in fresh food to a growing population in new neighborhoods beyond the traditional Jewish neighborhoods. The development and construction of new row houses in the northwest section provided an instant clientele for the self-service food market concept devised by Harry and Louis Manusov with their two stores (one in North Philadelphia at 22nd and Ridge Avenues). Furthermore, the increased use of individual automobiles after World War II necessitated the need for freestanding stores with their own parking lots. Jack Friedland and his young son, Marc, install a time capsule in the 300th Food Fair store, a chain that stretched up and down the eastern seaboard. (Courtesy Urban Archives, Temple University.)

Ten
NEIGHBORHOOD SHULS

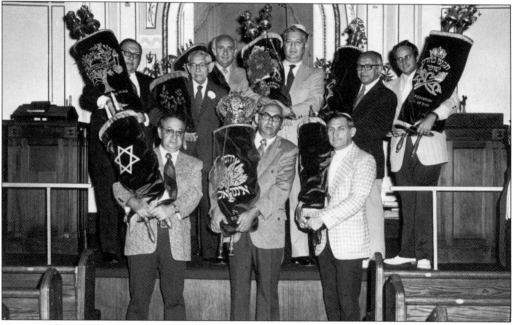

New residents who were "founding" new Jewish communities took on the time-honored responsibility of setting up new synagogues and *shuls*. Then, the very building of a neighborhood with a high concentration of Jewish people attracted even a greater Jewish population as new synagogues opened and the specific neighborhood established its reputation. More than 90 *shuls* had opened in the mid-1950s and provided the core of many Jewish blocks throughout both sides of North Broad Street. Congregation B'nai Jeshurun, formerly from Strawberry Mansion, decided to move as the neighborhood emptied of its Jewish people in the late 1950s. The *shul* relocated to Mount Airy at Stenton and Dorset Streets, until that neighborhood changed in the late 1970s. In this view, Rabbi Leonard Zucker leads his congregation's most precious belongings—nine Torahs—in a ceremony to install them in another leg of the B'nai Jeshurun legacy. (Courtesy Jewish Exponent.)

The Grand Rabbi Moishe Lipschitz came from Galicia to Philadelphia in 1915 and settled with his family at 943 North Sixth Street in the Northern Liberties section. Congregation Machzike Hadas served as home to his children, Freda, Harry, Nathan, Sarah, Osher, Zelig, Chaim, Uri, and to his wife, Chaya. The man with "a golden heart" strengthened the community with Jewish teaching and concern for the individual until he migrated to Jerusalem, Israel, in 1950. (Courtesy Freda Lipschitz Rosenberg.)

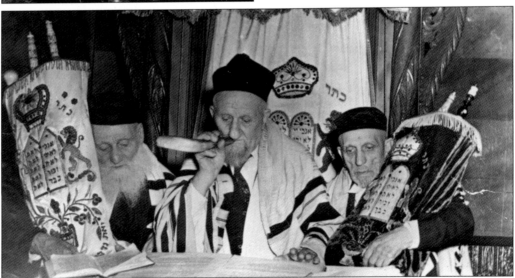

The Seventh Street and Girard Avenue neighborhoods sprawled seven blocks east of North Broad Street and stretched more than one mile northward with an eastern boundary at Front Street and its western boundary at the Pennsylvania Railroad past 10th Street. More than 44 synagogues operated in this community during the 1930s, including the large prayer chapel inside the Uptown Home for the Jewish Aged at Franklin and Poplar Streets. The residents themselves conducted the religious services and encouraged all its residents to participate. (Courtesy Lilly Ballen Pearlstein.)

The 22nd Street and Ridge Avenue business district supported the B'nai Israel synagogue located at 1709 North 17th Street with help of Morris Sheinson, the owner of a laundry business on 2100 Ridge Avenue. The religious affairs of the congregation were conducted by Morris, who was entrusted with the daily affairs of the Northern Chevra Kaddisha (burial society), located in North Philadelphia at Seventh and Parrish Streets. (Courtesy Si Sheinson.)

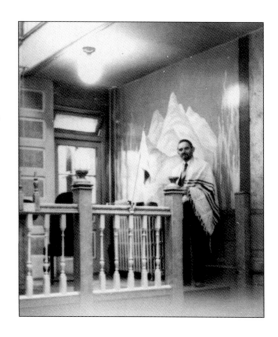

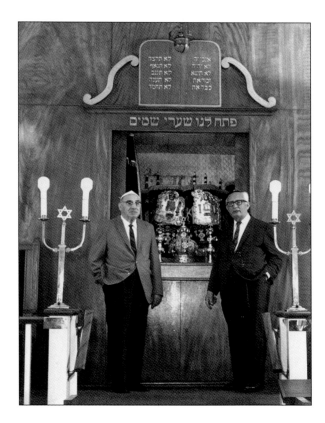

The 22nd Street and Cambria business district attracted Jewish merchants to the area where the new Shibe Park major league baseball stadium went up in 1909. Only three years earlier, the synagogue, Congregation Beth Abraham, had rallied around the National Free Loan Society. The synagogue hosted the famous filmmaker Siegmund Lubin, who created movies in fields near the synagogue. The congregation merged with Temple Beth Ami in the late 1960s. (Courtesy Louis Margulies.)

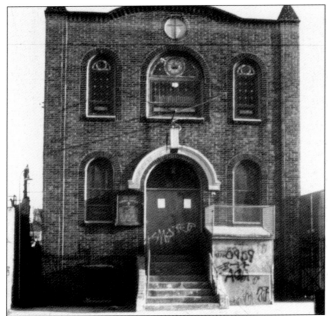

The B'nai Israel Congregation, founded at 506 East Erie Avenue, served a community of dry goods merchants. The orthodox *shul* led by Mr. Soltkin and benefactor Kalman Krevitz organized 35 Jewish families and built a freestanding synagogue in 1922 adjacent to the Taylor School. The Shamus, or caretaker, Rosen lived in the basement. After World War II, the congregation became conservative and allowed mixed seating of both men and women. B'nai Israel, led by Rabbi Benson Scoff, closed in 1964 as the merchants retired. (Courtesy Allen Meyers.)

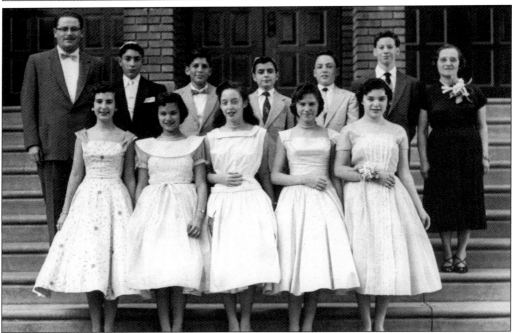

In the 1920s, Beth Judah synagogue served a growing and vibrant neighborhood in the middle of Logan and was situated on North 11th Street one block above its business district. The new freestanding synagogue was designed to blend into the surrounding neighborhood, with the same color bricks and high "bull nose" steps. In 1958, Rabbi Sam Woghlenter and Cantor Yehuda Mandell provided the confirmation class with great learning and leadership. The confirmants that year included Larry Richman, Barry Zalban, Rita Rosen, and Maury Brenner, all from Eva Pitlick's class. (Courtesy Rita Rosen Poley.)

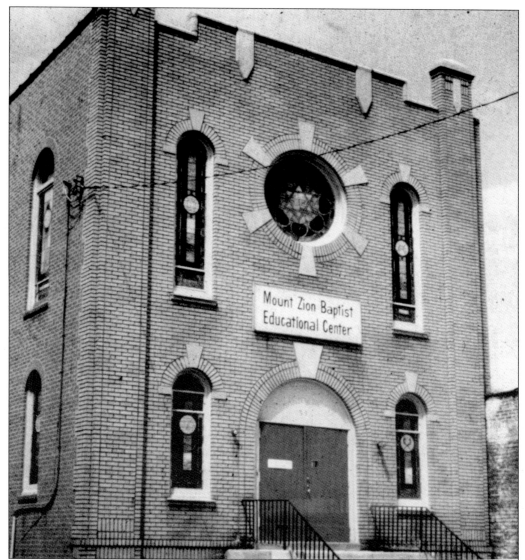

The Germantown and Chelten Avenue business district served as a base for Congregation Ahavas Chesed, which formed in 1906. Trolley car route No. 75 ran from Frankford to Germantown, where Jewish communities were cultivated by German Jews as they migrated farther northward. First known as the Germantown Hebrew Congregation, it later adopted a Hebrew name when it first met at 5610 Germantown Avenue above an old firehouse. Ellis Dashevsky, the benefactor of the *shul*, convinced Rabbi Gershon Brenner to build a freestanding synagogue on East Rittenhouse Street off Germantown Avenue. A large Hebrew school served more than 125 Jewish families into the late 1940s. Rabbi Morris Picholtz came from B'nai Jeshurun *shul* of Strawberry Mansion in the 1950s and led the Ahavas Chesed until it closed in the 1960s. (Courtesy Allen Meyers.)

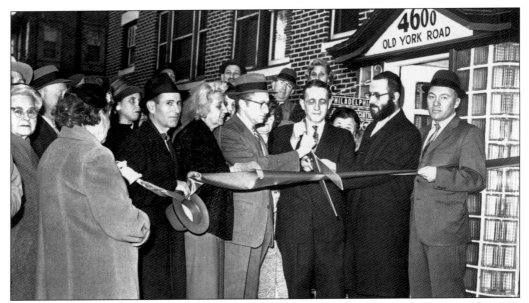

The Jewish community of Logan peaked in the early 1960s with a Jewish population of 12,000 and 12 synagogues. The neighborhood received a boost in its population as West Philadelphia and Strawberry Mansion ceased to exist as viable Jewish neighborhoods. The new Schuylkill Expressway, with a connection to Roosevelt Boulevard, brought more Jewish people to the area, and a large group of religious Holocaust survivors made this area their home, necessitating a new *Mikvah*, or ritual bath house, in 1961. The ribbon was cut at 4600 Old York Road by Rabbi Aaron Popack. (Courtesy Jewish Exponent.)

The Logan neighborhood achieved the status of a Jewish neighborhood in the 1920s, when churches were converted into synagogues. The Jewish population of the community exceeded more than 60 percent of the houses in the 1940s, when the Tolner Rebbe, Moishe Twersky, and his wife, Rifka, who lived in South Philadelphia, decided to move to Logan with their eight children in 1944. The addition of the Tolner Rebbe changed the whole nature of the community, with a shift to practical matters of everyday living according to Jewish Law. The synagogue closed 40 years later as one of the last synagogues in Logan. (Courtesy Jean Twersky Gordon.)

Congregation Emanu-El was founded in the 1920s and represented the new northern migration up the entire length of North Broad Street at the end of the Broad Street subway. The Jewish community started its third generation of communal life beyond the northernmost Jewish institution, the Jewish Hospital, when public transportation made it possible to commute downtown within 30 minutes. New housing, many public schools, and shopping districts provided a base for the Oak Lane community to grow and flourish. After World War II, Emanu-El built a second edifice, on the corner of Stenton and Old York Roads, with its attention to American architecture (the colonial period triangle) and the five windows, which represented the five books of Moses. The synagogue provided an auditorium and gymnasium for its youth. Sixty years had passed when, in the 1980s, Emamu-El closed its doors and merged with Melrose-B'nai Israel on Cheltenham Avenue.

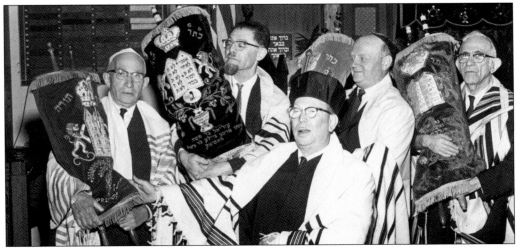

B'nai Israel congregation of Logan was founded in 1920 and absorbed B'nai Halberstam from the Northern Liberties section of North Philadelphia as many Jewish people migrated northward in the 1940s and 1950s. The welcome ceremony for another Torah scroll is similar to that of the new neighbor's arrival in the community. From left to right, Cantor Naftali Unger is joined by Jacob Rossman, Fred Wanger, Max Riser, and Ben Masel inside the *shul* at 10th and Rockland Streets in the spring of 1968. (Courtesy Jewish Exponent.)

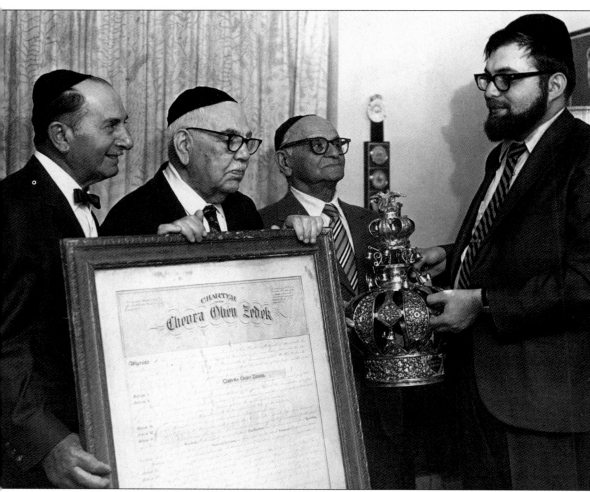

As Jewish people moved into Mount Airy, their allegiance to South Philadelphia, West Philadelphia, Strawberry Mansion, North Philadelphia, and Logan synagogues soon gave way to new community-based houses of worship. The combination of so many former Philadelphia neighborhood *machors* (leaders) allowed for the quick marriage of ritual and custom for the sake of survival. Congregation Ohev Zedek from Seventh and Oxford Streets merged with Aitz Chaim-Zickron Yaakov to form the new entity at 1201 east Mount Pleasant Avenue in 1968. Isadore Scheier, Heman Gross, Ben Shall, and Rabbi Tsvi Schur of the congregation celebrated the original Ohev Zedek's 82nd birthday in 1971. (Courtesy Jewish Exponent.)

Some congregations are very fortunate to acquire excellent rabbinical leadership in their formative years. Rabbi Sidney Greenberg, a graduate of the conservative Jewish Theological Seminary of America, accepted the pulpit and served his congregation for five decades. The beautiful synagogue built at Washington Lane and Limekiln Pike, off Ogontz Avenue, served the West Oak Lane and Temple Stadium area into the 1970s, when the move out the Route 309 expressway took Temple Sinai to the rural suburban town of Dresher, Pennsylvania, 10 miles farther out of the city.

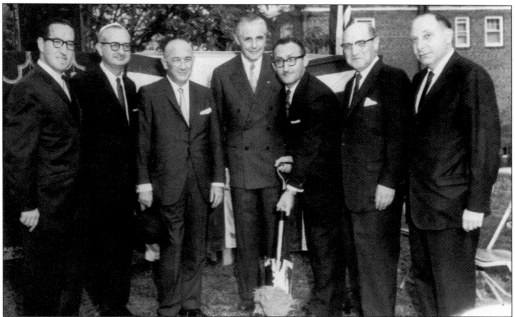

Many influential members of Congregation B'nai Jeshurun sought to bring their synagogue to the Mount Airy area after the population increase after World War II. Groundbreaking ceremonies took place at the new building at Stenton Avenue and Dorset Street in the early 1960s. The congregation stayed solvent until neighborhood change forced B'nai Jeshurun, which had absorbed Ahavas Cheses from Germantown, to merge with Beth Tikvah on the suburban side of Papermill Road. (Courtesy Jewish Exponent.)

The Melrose Jewish center, built on a strong social foundation of young Jewish families who bought new starter row houses in the Melrose Garden section of Philadelphia, was constructed only two miles east of Broad Street in the 1950s. The neighborhood surrounding the center lent itself to a self-contained community of conveniences, such as the Food Fair supermarket off Front and Godrey Avenues. Children went to the Finletter public school and later Olney High School. Cantor Pransky led the group of young families, but the center merged with the former B'nai Israel Congregation from Third and Tabor Roads in the 1960s.

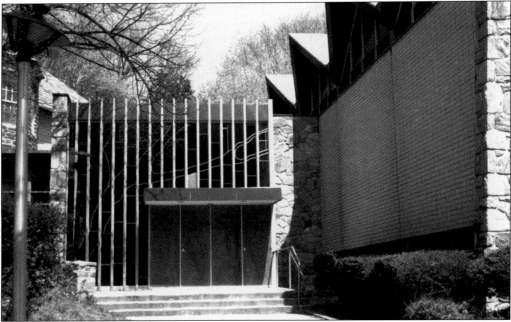

The formation of Beth Or, a reform congregation, in Mount Airy, began after World War II. Reform Congregation Keneseth Israel sought to relocate its facilities in the undeveloped wooded area of Ogontz and Cheltenham Avenues, but this did not materialize. Al Wilson led the group of local residents in 1954 to form the Mount Airy Reform Congregation to serve people who lived in the Temple Stadium area off Cheltenham Avenue. Rabbi Joseph Herzog, a product of Reform Congregation Rodeph Shalom, led Beth Or to build its new facilities at Mount Pleasant and Anderson Streets in Mount Airy.

Eleven

JEWISH CATERERS AND OTHER PROFESSIONS

The availability of Jewish and kosher food became a staple that attracted many people to different neighborhoods. Residents like Hy Getson, Rosenthal & Kauffman, Harry Davis, and many others made a living catering to the residents' need and desire for good food. In industries other than food, a decisive change occurred in the psyche of Philadelphia's Jewish population after World War I. A shift from menial service or factory jobs, such as cigar makers and needle points trades, to independent small business owners provided the cornerstone for a fundamental shift in philosophy on how the future generation of Jewish adults would enter the work force. Young people were heading off to colleges and universities in larger numbers and chose not to default into the same businesses and industries that their parents and grandparents had been in. In the late 1950s, the use of a cigarette girl (or old World War II pinup-type model) to open a catered affair in an assembly hall was very prominent. (Courtesy Peter Olster.)

Restaurant help in any generation is difficult to find. The secret of the Ambassador Vegetarian and Dairy restaurant—to hire the best staff and train and treat them well—differed from the other well-known eateries in the vicinity. The competition for good help is more than luck—it is selection and hard work to match people with various skills and desires into a working team. The other restaurants and catering halls near Marshall and Girard Avenues included Gansky's, Izzy's, Rosenthal & Kauffman, and the Capital. Ben Katz insisted on using only the best ingredients, and as his son, Allen, recalled that his father would arrive at 3 a.m. at the Dock Street wholesale food market four times a week to hand select barrels of herring. In the era of all-male waiters, this team includes Dave Sandler, Willie Lipman, Harry Dichter (a music sheet collector), Sam Bahr, Moishe Shisin, and Irv "Reds" Schwartz. They were known for their excellent service and the white folded towel draped over their serving arm. All the men belonged to the Hebrew Waiters Union. (Courtesy Allen Katz.)

The great hotels of North Broad Street had long waiting lists for reservations up to two years before the outbreak of World War II. Weddings, Bar Mitzvahs, and graduation parties headed the list for elegant Jewish affairs. The Broadwood Hotel competed for top honor in the city for Jewish social events and was complete with kosher kitchens supervised by Getson & Savdove caterers. The hotel touted itself as "First for Functions in Philadelphia." (Courtesy Robert Skaler.)

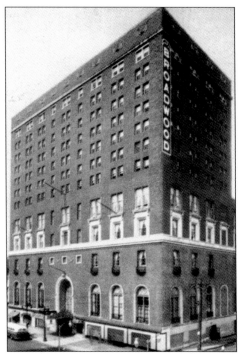

Bar Mitzvah affairs for American Jewish, first-born males turned into events that rivaled wedding parties in Philadelphia after World War II. Ben Katz and his wife, Anna, owners of the Ambassador restaurant, spared no expense in hiring Harry Davis caterers for their son's Bar Mitzvah at the Girard Plaza Ballroom on North Broad Street and Girard Avenue. Fish, beef, squab (poultry), smoked duck, and poached salmon were served to invited guests on Thanksgiving Day 1948. The ceremony took place at the Lubovitzer Congregation at 953 North Franklin Street. (Courtesy Allen and Jean Katz Schwartz.)

Sidney and Sue Tankin took exceptional pride in the Jewish catering business they owned, which flourished from the 1920s to the 1960s. The couple owed their fortune to longtime employees such as Payton Bell, Curtis Lee, and Haddie Powel, who followed the recipes of the family and delivered exquisite service. The business served as the primary caterers for the leading synagogues of Har Zion and Beth Sholom from its establishment at 4708 North Broad Street in Logan. On the wedding day of the Tankins' daughter, every detail was fine tuned for the bride, Sheila Tankin, and the groom, Ed Hofferman, who exchanged marriage vows at Har Zion. (Courtesy Sheila Tankin Hofferman.)

The combination of good music and great food is hard to match at any price. The assortment of liquors is just as important and the care and attention given by the bartenders to the guests. The Music Association included Lou King's Band, Leo Toufer, and Don Mone. The use of the awning inside as the motif made this family affair a truly memorable one. (Courtesy Sheila Tankin Hofferman.)

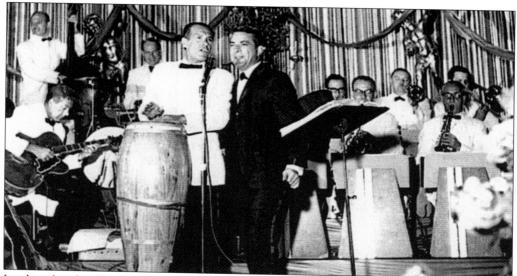

Leading bands offered the most up-to-date music and themes for the times in the 1950s. Bandleader Jay Jerome often performed with others who had their own bands, including Bobby Roberts and Lou Gold, as contracts were doled out by the entertainment union of Jewish musicians. A famous singer known only as Fernando accompanied many bandleaders with big musical instruments to blare out the contemporary Latin beats, which featured Cuban and South American tunes. (Courtesy Sheila Tankin Hofferman.)

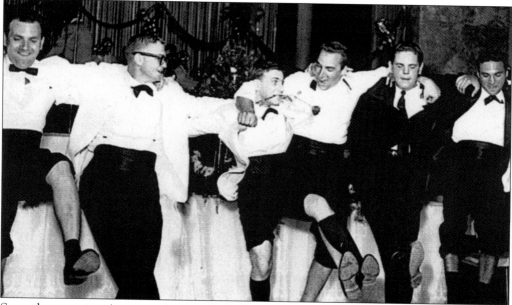

Second-generation American Jews in Philadelphia recalled their European roots in centuries-old dances. Ladies dancing with ladies and men dancing with ladies, respecting the Jewish laws by sharing a handkerchief, cannot compete for the tumultuous laughter heard when men line up in a chorus line and do world-class Jewish dances. Ushers and friends Hal Levy, Burten Wittenberg, Arnold Stern, Steve Sable, and Myron Pearlstein show off their legs in honor of Ed Hofferman's wedding to Sheila Tankin. (Courtesy Sheila and Ed Hofferman.)

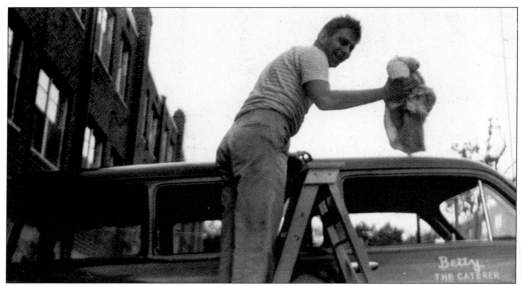

Catering requires long and awkward time schedules. For Burton and Betty Olster, the choice to join forces and operate a business all their own led to many sacrifices. The chore of delivering the food from one place to another was Burton's; he began with wood-paneled station wagon in the 1950s. Serving great dinners became a tradition with little fanfare until Betty the Caterer was called upon to create and serve an Israel Bonds Drive dinner with Golda Meir in attendance in 1966. Peter Olster carries on his parents' tradition of providing memorable meals to the community at important events. (Courtesy Peter Olster.)

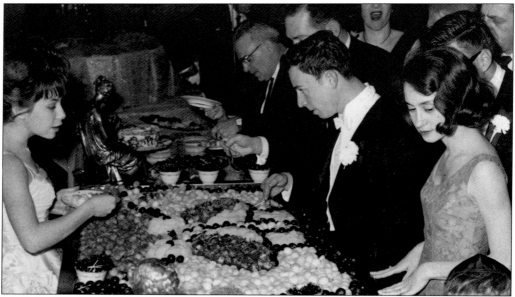

The Shelron cater hall was a favorite spot to have a catered affair in the 1960s. The Sidney Kowit family incorporated their business by naming their catering hall after their children, Shelly and Ronnie, and became a Jewish household word in the era of beehive hairdos and white cat's-eye reading glasses. A trademark of the Shelron included the fruit dessert buffet, enjoyed here by Rita Rosen at her wedding to Yeshoshoa Buch in January 1964. (Courtesy Rita Rosen.)

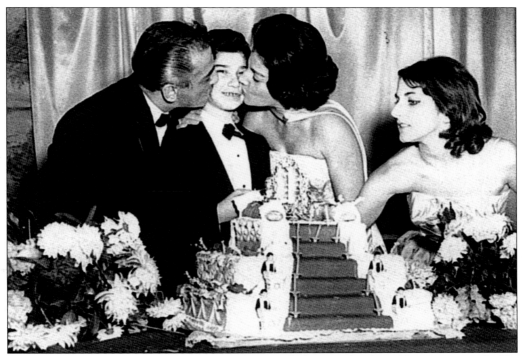

Ronnie Davis gets a lot of attention for a 13-year-old boy on the day of his Bar Mitzvah. His parents, Harry and Lillian Davis, were kosher caterers in Philadelphia. The scene is at the Girard Plaza, 922 North Broad Street, where the whole Davis family, including Ronnie's siblings Phyllis, Alan, and Stewart, join the celebration in the 1950s. (Courtesy Harris Davis.)

The demand for varied kosher cuisine evolved into themed food stations in the 1960s. The honorable profession of Jewish catering was introduced to Harry from his uncle, Jack Alexander, who ran his own successful food business from the Majestic Hotel at North Broad Street and Girard Avenue. Ballrooms up and down North Broad Street included Roney Plaza at Glenwood Avenue and North Broad Street, the Drake Hotel, the Alpha, and the Ben Franklin Hotel. This buffet attendant dressed up as an Arabian knight. Today, Harry Davis still works every day at his business, which evolved into My Caterer. (Courtesy Harry Davis.)

Social halls and auditoriums provided a venue for functions inside newer synagogues in the 1950s and 1960s. The Louis Kasoff Auditorium at Congregation Emanu-El doubled as the overflow room for congregants during the High Holidays and was an elegant social hall for the rest of the year. Judy Small and Manny Reider (seated, center) celebrated their wedding reception here on June 21, 1959. In attendance at the head table are, from left to right, Fanrose and Philip Small (the bride's parents) and Anna and Joseph Reider (parents of the groom). (Courtesy Manny Reider.)

Bandleaders, including Marty Portnoy, Abe Neff, Jules Helzner, Dave Kantor, Eddie Lit, and Bob Krum, entertained thousands of guests at hundreds of wedding in the second half of the 20th century. The bands played at many Jewish Veterans of Foreign Wars affairs, and the Swan Club and Wagner Ballroom above North Broad Street and Olney Avenues. The bandleader became the agent to get jobs for his group, which Portnoy advertised as his "Saxophone and Orchestra." (Courtesy Marty Portnoy.)

After World War II, Jewish caterers competed for an exceptional number of wedding affairs and graduation parties. Each organization had to appear different from each other in order to attract the market share of the trade. Norman Blankfield started out in a luncheonette at 222 North 11th Street serving meals to the nearby factory workers. He graduated to a kosher caterer who distinguished himself from the crowd by having his entourage of waiters stroll through the reception area with the lights dimmed as they carried "flaming Cornish hens" to the tables. (Courtesy Louis Blankfield.)

The attention to details of good Jewish cooking in many Jewish facilities came as the result of the selection process of quality ingredients from reputable suppliers such as Weinfeld & Zukerman wholesale groceries, Cross Brothers, Philadelphia Dressed Beef meat packers, and Liss Bakery. Norman Blankfield liked his work so much that he was present at many of the affairs he catered. (Courtesy Louis Blankfield.)

Many family members often took part in their family's catering business. The daily communication from Norman and Jean Blankfield to their son, Louis, and then to Louis's daughters, Tammy, Dena, and Micki, made the transition of ownership of the business from one generation to the next very smooth. (Courtesy Louis Blankfield.)

The days when Rabbis Abraham Poupko and Alexander Levin personally insured the *Kashuruth* (adherence to Jewish laws) concerning food preparation have faded; the task is now taken up by the Philadelphia *Vaad*, or Jewish board of religious people who oversee such affairs. Since the recommendation of a respected elder in the community is sometimes no longer available, branding the name of a longtime Jewish family business is no simple task, as Louis Blankfield's daughter, Tammy, who now runs the business, will tell you. Caterers today brand many of the items and tools they own, even delivery trucks, with their logo for instant name recognition.

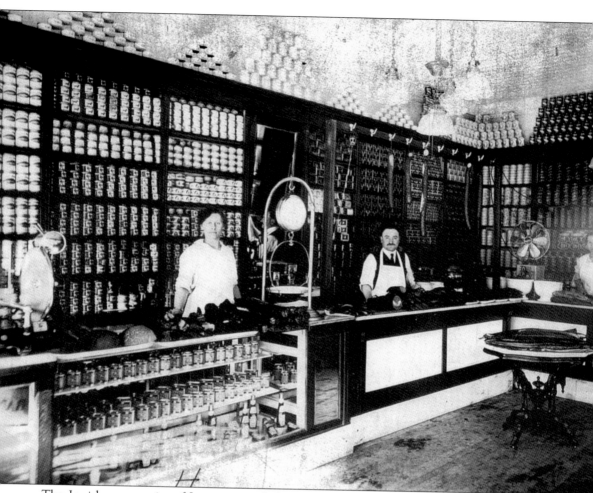

The Jewish community of Logan expanded in the 1920s as more row houses with fenced-in porches were constructed. The opening of the Broad Street subway and synagogues led to the opening of the famous Ulitsky Jewish Delicatessen, at 11th and Louden Streets, in 1924. Sonia and Hyman Ulitsky made sure each jar was placed exactly in order on their shelves. The wonderful aromas of fresh kosher salami and smoked fish are forever ingrained in our souls. (Courtesy Jean Ulitsky Gralnick.)

Left: Foreign-born Jewish scholars transplanted themselves to Philadelphia. Dr. Joseph Reider came from Russia in 1910 and gained his doctorate from Dropsie College in 1913. (Courtesy Manny Reider.) *Right:* Helene Hanff was a writer from the 1600 block of Diamond Street in North Philadelphia. Her famous book *84 Charing Cross Road* resulted from communications with her pen pal, Frank Doel, in London, England. (Courtesy Carolyn Kayson.)

Phil Rosen grew up in North Philadelphia during the late 1930s and 1940s along North 22nd Street. His parents, Robert and Helen, owned a discount store at 22nd and Cambria Streets, and he often went to visit his grandparents' store some six blocks south at 22nd and Sargent Streets. Rosen also delivered Jewish newspapers to 80 homes nearby. He attended Temple University and later became a social studies teacher at the new Northeast High School on Cottman Avenue. Later, an association with Jacob Riz, a Holocaust survivor who opened a museum in his basement, led Rosen to direct the Philadelphia Holocaust Museum. (Courtesy Phil Rosen.)

Left: Edward Shil had roots in South Philadelphia and North Philadelphia, where his family owned a cigar factory. Shil grew up in an era when playing touch football on North Ninth Street and dodging the passing route C bus was a sport in itself. *Right:* Popular talk radio host Irv Homer grew up with his grandparents at 1929 North Seventh Street near the old northeast Jewish orphanage home. (Courtesy Irv Homer.)

Alfred P. Orleans, a Russian-born Jewish immigrant, came to America in 1906. A prominent member of the Pannonia Beneficial Association, Orleans amassed wealth and influence from the real estate and insurance business. His company's push to keep building houses right even through the Great Depression kept him in business; he was still a household name in the 1950s, when development began to take place north of the city. His legacy is best understood by his vast amount of charity and his contribution to the community at large, especially the agency (A.P. Orleans Vocational Services) that bears his name in Northeast Philadelphia on Rhawn Street. (Courtesy Jeffrey Orleans.)

Joel Shoulson, a name known far and wide through the Philadelphia metropolitan area as a great person and the leading *Mohel* (circumcision performer), grew up at 5219 North Broad Street near the Jewish Hospital. Like his father and six generations before, Shoulson carried on the family occupation. Shoulson is shown with his father, Morris Shoulson. The father and son team developed the Mogen circumcision clamp, which they used in their profession for 40 years. (Courtesy Joel Shoulson.)

Arlene Vinikoor grew up in Logan before relocating to Northeast Philadelphia. Vinikoor created JOY (Jewish Outreach for special Youth), a program to provide for learning disabled Jewish children the same opportunities other children enjoyed. The program gained support and funding through Gratz College of Community Services beginning in 1977. The program touched many Jewish lives at leading synagogues and social agencies in the Delaware Valley. (Courtesy Arlene Vinikoor.)

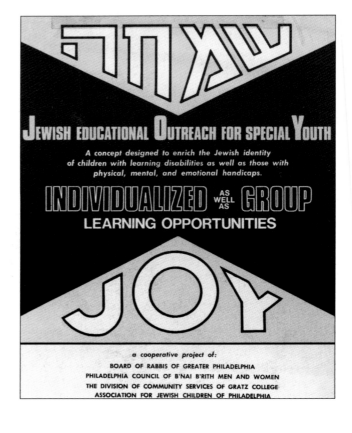

שאר רוח

JEWISH EDUCATIONAL OUTREACH FOR SPECIAL YOUTH

A concept designed to enrich the Jewish identity of children with learning disabilities as well as those with physical, mental, and emotional handicaps.

INDIVIDUALIZED AS WELL AS **GROUP**

LEARNING OPPORTUNITIES

JOY

a cooperative project of:
BOARD OF RABBIS OF GREATER PHILADELPHIA
PHILADELPHIA COUNCIL OF B'NAI B'RITH MEN AND WOMEN
THE DIVISION OF COMMUNITY SERVICES OF GRATZ COLLEGE
ASSOCIATION FOR JEWISH CHILDREN OF PHILADELPHIA

Left: Drs. Harold and Miriam Shore operated their practice in North Philadelphia on the outskirts of the Strawberry Mansion section at 2727 West Lehigh Avenue. Legend has it that Harold proposed in 1948 by asking Miriam, "Would you like to work with me in my office?" (Courtesy Miriam Shore.) *Right:* Dennis Lyons, from Logan, took his high school education very seriously and went on to become an optometrist who practices down by the shore. (Courtesy Dennis Lyons.)

Family pediatricians are a Jewish mother's best friends, as attested by Dr. Stanley (Shep) Goren, originally from 4807 north Seventh Street. Goren owes his livelihood to his upbringing in Logan, where he spent most of his time with the children of the corner merchants Sable's fish, Mandel's grocery, Rosenberg's kosher meats, and Dave's fruit market. He was recently in charge of a reunion of fellow Loganites. He once said, "I never found a kid that I could not love." (Courtesy Janice and Stanley Goren.)

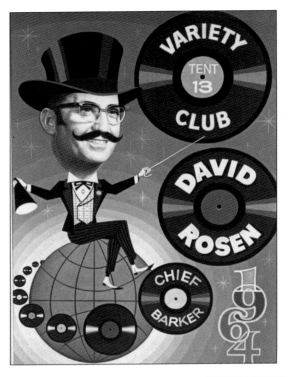

The music business centered at one time in North Philadelphia on North Broad Street among all of the well-known hotels. Universal Records, at 919 North Broad Street, was run by David Rosen and was the largest distribution of music, vending machines, and amusement coin-operated machines on the eastern seaboard in the 1950s. The demand for pinball machines and jukeboxes to play the daily turnout of new rock and roll music necessitated the construction of a manufacturing plant at 22nd and Master Streets. (Courtesy Elliot Rosen.)

The era of people conversing on marble stoops on hot summer nights seemed only a luxury for Kal Rudman, who helped his father, Benjamin, and his mother, Lena, in their corner delicatessen at Seventh and Berk Streets. Rudman, a graduate of the Fergenson School at Seventh and Norris Streets and winner of the Simon Muhr award, went on to Central High School and developed a sense of what Philadelphians liked to hear on their new transistor radios. His knack for picking or predicating what songs and which artists could top the charts led to his creation of the Friday Morning Quarter Trader and a position as editor at *Billboard* magazine. (Courtesy Kal Rudman.)

Logan resident and longtime newscaster Steve Levy's outstanding trait growing up and attending Olney High School (Class of 1965) has been his trademark through his life—leadership. As president of his senior class, Levy said, "As we separate to go on our chosen paths, Olney High School gave us the opportunity to learn to live and cooperate in society." Levy has earned the respect of native Philadelphians through his concentrated work in television reporting and as an anchor at NBC Channel 10. (Courtesy Steve Levy and Dennis Lyons.)

Edward Felbin, better known by his professional name, Frank Ford, hailed from Logan as well. Born in 1916 as the son of a grocery store merchant from 4754 North 10th Street and later 76th and Ogontz Avenue, Edward sought his future both in radio and on Broadway. By 1955, he joined with Shelly Gross and Lee Gruber to found the Valley Forge Music Fair. He later turned to late night talk radio on WCAU and WPEN. Adopting the stage name Frank Ford spoke to his loyalty to the Frankford section. (Courtesy Edward Felbin.)

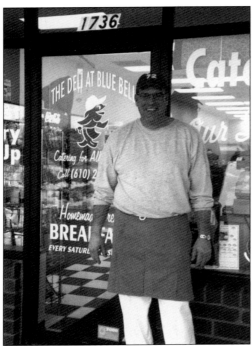

Ben Baskin, a former resident of West Oak Lane who played sports at the Finley playground at Mansfield and Upsal Streets, opened the Blue Deli on 1739 De Kalb Pike, featuring products cut on a dedicated kosher slicer and "nostalgic" smoked fish items. Many baby boomers recall the old-fashioned booth service of yesteryear's luncheonette menus, now available again at the Blue Deli. (Courtesy Ben Baskin.)

Longtime resident of the North Broad Street community, Manny Reider, and his wife, the former Judy Small, have considered this section, near 66th and North Broad Street, from the time they were children to now, as grandparents. The couple live less than a mile away from where they lived as children. Manny, a model builder, belongs to the local trolley car association and maintains a full floor of model railroad communities in his home, complete with realistic model landscaping, trees, and figurines. (Courtesy Manny Reider.)

Twelve

A RENAISSANCE

As Jewish Philadelphians look back on their accomplishments in the 20th century, there can be seen achievements and improvements. The yearning for yesterday will never cease, as memories and untold stories revealed at neighborhood, school, and professional gatherings become so prevalent. The story of how the Jewish people built a bridge to the future is an ongoing tale unto itself. The rebirth, renewal, and redevelopment of the North Broad Street area signify the desire for neighborhood residents to hold on to the past while actively shaping their future. Bart Blatstein, who grew up in the Oxford Circle section, is the grandson of a *schmatta* (cloth and rag) dealer who conducted his business at Second and Fairmont Streets. Blatstein entered the business of property management and investment. He is pictured here with his latest plans to build a new community on 18 acres of the former Schmidt's brewery at Second and Girard Avenues. (Courtesy Bart Blatstein.)

Almost 120 years have passed since the original Adath Jeshurun synagogue, right, was dedicated in 1886. The rebirth of the area in North Philadelphia, complete with new homes for moderate income residents, represents a return to the urban environment. A commitment by the Philadelphia Housing Development Corporation to construct affordable, twin-family homes provides hope for a city on the road to rebirth. (Courtesy Allen Meyers.)

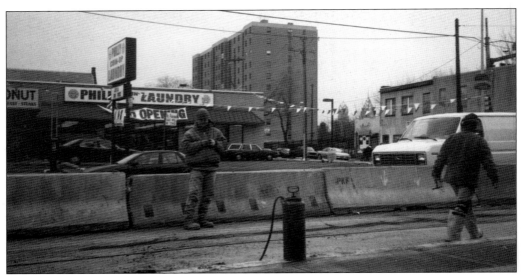

The return of the route No. 15 trolley car to its original route on Girard Avenue is at hand. The route is to be in operation in 2003, using new cars operated by SEPTA. Route 15, as it once did, will cross the Schuylkill River and pass the Philadelphia Zoo and Memorial Hall. The cars will be built with a grant from the federal government. (Courtesy Allen Meyers.)

Renowned Philadelphia icons Betty and Joseph Liss are known all over the city for their inspiring success story. The couple, who once owned only a small corner bakery, now operate a commercial wholesale business, complete with a modern commercial bakery at 5698 Rising Sun Avenue. During the 1970s, when competition from supermarket chains threatened the business, the question they faced was whether to close and allow their rye bread, bagels, cakes, pastries, and brownies to fade into history. The answer was a resounding "No!" and the company blossoms today, as it has since 1949, under the careful guidance of the Liss's son, Jon. (Courtesy Betty Liss.)

Great Philadelphia institutions remain a vital part of the city's well being. Kaplan's Bakery, at Third and Poplar Streets, is just one of the wonderful success stories in the city. Founded in 1916, when the community catered to many east European Jews, the bakery flourished in the Northern Liberties section. The company developed the Gold Medal flour brand, legendary throughout Philadelphia and much of the nation.

Many groups, individuals, couples, neighbors, families, schools, organizations, and synagogues throughout the city join in the nostalgia of holding reunions. These events in the latter part of the 20th century beat any block party or picnic in Fairmount Park with phenomenal attendance. Above, it is as if time has stood still for Dave Baron and Joe Simone, shown at the Logan Reunion at the Ashbourne Country Club on October 8, 2001. Only the night before, a Mount Airy–West Oak Lane reunion took place. (Courtesy Dave Baron.)

Some Jewish groups make it their business to meet once a month to keep that sense of their past alive. The boys and girls from the Jewish Orphanage at Chew Avenue and Church Lane enjoy dinner at the Casino Deli on Welsh Road every month. The group, led by Herb Lyons, feels that a family is a family even if the members are not related by blood. Irv "Bullethead" Lomis displays an American flag in front of a mural on the wall of the old Earle Theatre downtown. Others in attendance usually include Nathan Goodman, Stan Segal, Roslyn Kaplin, Marlene Kenny, Maurice Karen, Rita Kligamn, Mollie Porter, and Morris Borman.

Renewal and rebirth go hand in hand for the Congregation Mikveh Israel, Philadelphia's first synagogue, founded in 1740. Through three buildings and synagogues, Mikveh Israel led the city in every aspect of Jewish life until 1976, when it decided that it should return to its roots and relocate downtown, where it had started. The new synagogue, north of Fifth and Market Streets, has collected many treasures of the community, including the statue of Religious Freedom, and proudly coexists with the National Museum of American Jewish History.

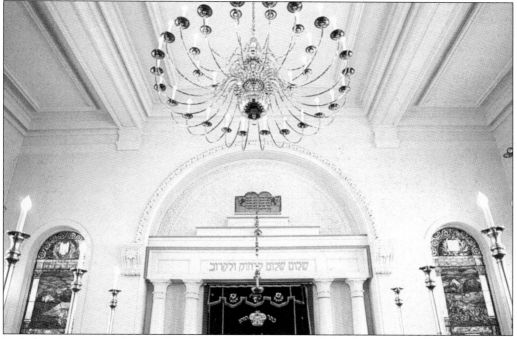

Rededication is part of renewal and rebirth for the Henry S. Frank synagogue, built in 1901 on the grounds of the Jewish Hospital south of North Broad Street and Olney Avenue. In the 1940s, the synagogue conducted daily and weekly prayer services with Rabbi Morris Shoulson as its spiritual leader. The transformation of the Jewish Hospital into a major medical center divested itself of any religious function in the mid-1950s, and the synagogue closed. By the 1980s, a resurgence in the Jewishness of the institution appeared in vogue. The renovation of the synagogue marked the 60th wedding anniversary of Julius and Eleanor Klein, joyfully contributed by Robert, Levoy, and Judy Klein Franken in October 1984.

Families do make a difference. Many faces of family members have been reduced to just photographs in our lifetime as cherished ones pass away, yet their voices ring out with clarity and a distinct message to us. The Wolf family is shown at a huge family Passover Seder held in Rodeph Shalom suburban synagogue in the 1990s. The Jewish people of this community include descendants of Max Kohn, Edwin Wolf, author of *History of the Jews of Philadelphia*, Robert Wolf, and the Fleisher family, through marriage. The *Kovad* (honor) goes to a special individual who understands and appreciates the meaning of family, especially when the patriarch or matriarch is no longer living. Although our old Jewish neighborhoods are gone, they once thrived on close family ties that must remain an ingredient of our American Jewish tradition today and into the future. The Hebrew inscription above the gathering translates as, "Know from where you came and where you are going and before whom you will have to give Judgment and Accounting." (Courtesy Ruth Fleisher Kohn and Lucille Fleisher Bernstein.)

The Jewish community around North Broad Street prided itself on being comprised of tight-knit families that settled close to one another and shared a common interest in the improvement of their lives through the education of their children, involvement in religious and public causes, and participation in community institutions. The community still felt, and feels, united, even as it expanded and migrated farther north and northwestward, a testament of its lasting bond.

To learn more about the Jewish communities of Philadelphia, you may contact Allen Meyers, 11 Ark Court, Sewell, New Jersey, 08080; telephone (856) 582-0432; fax (856) 582-7462; e-mail ameyers@net-gate.com. You may also visit his Web site at www.jewishphillyneighbors.com.